Prais... Ow...

4/08

"Nancy Peacock has written an instant classic filled with wisdom, hu... ...der, and lit... ...le books ab...

...gate Hill

"Le... ...ecleaner, Na... ...era.' Her ac... ...ngs soar int... ...al labor, an... ...nd detritus...

...uthor of ...d White

"A... ...n of uncer... ...eacock's wo... ...in, and hop... ...w, then y...

...adilly

"... ...weeps a... ...g and h... ...riter. A... ...about h...

...Others

A Broom of One's Own

ALSO BY NANCY PEACOCK

Life Without Water
Home Across the Road

A Broom of One's Own

Words on Writing,
Housecleaning, and Life

NANCY PEACOCK

HARPER PERENNIAL

NEW YORK • LONDON • TORONTO • SYDNEY

HARPER ● PERENNIAL

The essay "Enquiring Minds" was previously published in the *Southern Arts Journal.*

Excerpt from *Rumi: The Book of Love* by Coleman Barks (HarperSanFrancisco, 2003) reprinted by permission of the author.

Excerpt from "Valentine for Ernest Mann," *Red Suitcase* by Naomi Shihab Nye (BOA Editions Ltd., 1994), is reprinted by permission of the author, 2007.

Excerpt from *Write Your Heart Out* by Rebecca McClanahan (Walking Stick Press, 2001) is reprinted by permission of the author.

The names of some individuals have been changed, and identifying features, including physical descriptions and occupations, of other individuals have been modified in order to preserve their anonymity. In some cases, composite characters have been created or timelines have been compressed, in order to further preserve privacy and to maintain narrative flow. The goal in all cases was to protect people's privacy without damaging the integrity of the story.

P.S.™ is a trademark of HarperCollins Publishers.

HarperCollins books may be purchased for educational, business, or sales promotional use. For information please write: Special Markets Department, Harper-Collins Publishers, 10 East 53rd Street, New York, NY 10022.

FIRST EDITION

Designed by Sarah Maya Gubkin

Library of Congress Cataloging-in-Publication Data is available upon request.

ISBN: 978-0-06-135787-9

08 09 10 11 12 ID/RRD 10 9 8 7 6 5 4 3 2 1

THIS ONE'S FOR BEN

Acknowledgments

Special thanks goes to:
Ben Campbell for excellent editing suggestions, always being there and putting up with me.
My agent Sally McMillan.
My editor, Carolyn Marino, and her assistant, Wendy Lee.
Members of my writers' group: Joyce Allen, Paul Mihas, Stephanie Smith, and especially Wendi Barry, who suggested this book.

"Until the Industrial Revolution, humanity accepted the cyclical nature of life. Nature's tides of composition and decomposition turned the small into the big and the big back into the small. Common sense held that over time all beings would find their way to dust and that dust itself formed a barrier between the visible and the invisible that could not be negotiated by the living."

Dust: A History of the Small and the Invisible

JOSEPH A. AMATO

Contents

Two women are walking down the road and pass a frog sitting in the grass. "Hey," says the frog.

"Wow. It's a talking frog," says one of the women. She picks the frog up and holds it in her hand.

The frog says, "Listen, I'm not really a frog. Actually, I'm a critically acclaimed writer. A spell was cast on me and I was turned into a frog. But if you kiss me I'll turn back into a critically acclaimed writer."

"Well, I'll be damned," says the woman, and puts the frog in her pocket.

Her friend asks, "Aren't you going to kiss it?"

And she answers, "Hell, no. I'll make a lot more money with a talking frog."

1

ENQUIRING MINDS

Mrs. Clark and I always took lunch together. She set a place at the breakfast bar for me right alongside her place. Two paper towels spread out to put our food on. I would pull my lunch out of my soft cooler. It was different things on different days. Sometimes an egg-salad sandwich, but usually a hodgepodge of leftovers. Mrs. Clark's lunch was almost always leftovers, too. If it was summer, she ate a raw hot pepper from her garden. And if it was autumn, she set out a tub of refrigerator pickles and let me help myself. By the time lunch was being served, *The Price Is Right* was on TV and I'd reached the back of the house. If I had been in the house alone, I would

have finished up the bathrooms before I sat down to eat. In the housecleaning trade, bathrooms and kitchens and mopping are called wet-work and I preferred to have it all behind me before lunch. It was hard to face wet-work after eating. It was not so hard to face the last bit of dusting and vacuuming and replacing the rugs.

But I was never alone in Mrs. Clark's house. She didn't like for me to be there when she wasn't. I had even been asked to rearrange my schedule to accommodate a doctor or dentist appointment. She kept up a steady complaint about the price, too, telling me at every opportunity it was high enough that I should provide the garbage bags as well as the cleaners and vac bags. If I hadn't liked her so much, I would have dropped her in a minute. But I did like her. She was old and old-fashioned and I liked the way she lived. At eighty-three, she still gardened and canned and pickled and put up produce in the freezer in the garage.

I liked her house too. Everything was neat and organized and the house itself was a marvel. It was built by her late husband, and in one place, the gold-toned knotty pine paneling opened to reveal a desk with cubbyholes and shelves above it. The last papers of the late Mr. Clark's construction business were stuck to a nail hammered through a small board. It was as if they waited for him to return and get two-by-fours at the old price.

There was a picture of Mr. Clark in the living room, a black-and-white photograph of a handsome young man in a military

uniform. From the same era was a picture of Mrs. Clark. She was drop-dead gorgeous, not in a glamorous, made-up kind of way but more in a healthy, capable kind of way. I bet she was a good girlfriend, and after the war, a good wife. She told me several times that when Clark (she always called him Clark) was deployed overseas, they worked out a code together. The first letter of every paragraph in his correspondence to her would spell out his location. That way she would always know where he was. "And I did," she'd say. "The censors never caught it."

I loved to hear Mrs. Clark tell stories. Sometimes she trailed me around and talked about Clark while I dusted the living room or cleaned the kitchen. I knew a lot about Clark. I knew that whenever someone dropped by to visit, he would say, "Come on in this house." And I knew he always gave bags of apples and oranges for Christmas. And I knew he'd fallen off a roof once and was out of work for a month. Mrs. Clark could tell me which houses along her street her husband had built and who had built all the others.

He died at home, in the house that I cleaned. He was sick a long time and one day their daughter Patricia was in the bedroom with him and he passed away with Mrs. Clark just on the other side of the wall he'd built. Mrs. Clark told me about Patricia coming into the living room and saying, "He's gone, Mama," and Mrs. Clark saying, "And you didn't come get me." I could tell that it still upset her.

"He might not have been able to go with you in the room," I told her. "I'm sure it was hard to leave you here."

Mrs. Clark looked away. "Well, there won't ever be another like him," she said.

She had a guitar in her closet and one day I asked her about it. "Did Clark play?"

"It's mine," she said.

She brought it out, slung the strap over her shoulder, tuned it, and picked a fast song. Then the guitar went back into the case and the case went back into the closet.

All the closets were lined with cedar and in the fall there would be box tops spread with newspaper and filled with green tomatoes picked just before first frost. I loved the seasons in Mrs. Clark's house. They had as much to do with the garden as they did with holidays, but holidays were clearly important. There were pictures to prove it. Her family took pictures of everything. Besides fifty years' worth of Christmas trees and Thanksgiving dinners, there were pictures of mundane things, like Patricia and the tenant from the garage apartment shoveling snow off the driveway, and even one of the big hole in the backyard, where the water department dug up an old gas tank.

Mrs. Clark kept the pictures arranged in albums. They marched in a neat chronological parade along one of the built-in shelves in the living room.

At Christmas she got cards from everyone who had ever

rented the apartment above the garage or the attic bedrooms
that were now closed off. She taped the cards to the doorframe
between the kitchen and the living room. This was when Mrs.
Clark was most likely to take her picture albums out and point
to a card and then the picture of the person who had sent the
card.

That she had pictures of every tenant they'd ever had
amazed me. It amazed me even more that Mrs. Clark knew
their names, and still got cards from them. Sometimes she
pointed to photos of the kids, or the couple she and Clark went
out with every Friday night. Once she pointed to a picture of
their maid, a smiling black woman named Real.

I asked Mrs. Clark about it several times when she first
showed me Real's picture. "Real? Her name was Real?"

"Yep. Real."

"That's a great name," I said, cataloguing it in my mind for
a future character.

"She was a great woman," Mrs. Clark said. "She was with
us seventeen years. Came in every day. Got sick and had to quit
and we miss her."

I tried to imagine Real. She probably dusted many of the
same things I was dusting and she probably got along with
the Clark family pretty well. They were a happy bunch. They
weren't mean and they worked hard and they didn't expect
miracles and there were certainly worse white people to work

for. But I bet it was hard on her too. Real must have had her own children to tend to. I'm sure there were meals to fix at home, floors that needed sweeping and mopping, dishes that needed washing, and sheets that needed changing. I could sympathize with Real regarding that, because for me this has always been one of the toughest things about working as a housecleaner. I scrubbed and dusted and mopped all day long and then came home to a dirty house. I imagine this irony was not lost on Real.

But Real wasn't the only maid in Mrs. Clark's scrapbook. I'd landed there too. There was a photo of me standing in the kitchen, the taped Christmas cards behind me. I have managed a smile, even though I hate having my picture taken and I especially hate it during a day of housecleaning. The trade shows on me. It shows in my frumpy, long-sleeved T-shirt and in the fabric of my jeans puddling toward my sneakers and in the yellow rubber gloves I clutch in one hand. I look fat and old and worn-out. Just thinking about this picture makes my lower back ache.

But in Mrs. Clark's scrapbook I am redeemed, for lack of a better word. The next page holds a newspaper article about me and there's the picture that my ex-boyfriend took. In it my hair is long and dark and I look pretty. You wouldn't even know it was the same person. The article reviews my second novel and quotes me in places, but there is no mention of housecleaning.

Maybe this is good. Maybe this is bad. All I know is that it wasn't exactly a secret but it wasn't exactly well received either.

Sometimes I felt that people who interviewed me or met me on book tour were embarrassed when they found out I cleaned houses for a living. I'm sure that many of these people had women coming into their own homes and cleaning for them, so I don't know if they were embarrassed for me or for themselves. I do know that their embarrassment leaked over to me and became my embarrassment too.

One man at a literary cocktail party burst out laughing when I told him, after being asked what my day job was, that I cleaned houses for a living. He thought I was deadpanning, and damned good at it too. "I'm not kidding," I said. "I clean houses for a living." I could see him pulling himself in, filtering this information through everything he thought he knew about published novelists. His was the most overt reaction I'd ever experienced.

Mostly I just saw a brief change in people's eyes. It didn't take loads of intuition to know what was going on behind the irises. Like maids everywhere, like Real, there were things I just knew. It always made me want to skulk away and plump the pillows on the couch, straighten the pictures on the walls, help the help pour the wine and offer the shrimp and stuffed mushrooms. But then I've always been uncomfortable with the nebulous task of mingling. I am a lot more comfortable taking

care of a task that has a beginning, a middle, and an end, like cleaning a house or writing fiction.

Finally one article in a national newspaper did mention my work as a housecleaner, and I never would have known about it if not for Mrs. Clark. The article came out on a Tuesday, the very day that her house was on my schedule. I would be there by ten a.m. but Mrs. Clark couldn't wait that long. I was eating breakfast when she called.

"Nancy?"

"Yes."

"This is Mrs. Clark. Congratulations. You're in the *National Enquirer*."

"What?"

She repeated.

My mind stumbled around like a drunk on acid. Had she said the *National Enquirer*?

"The *National Enquirer*?" I asked.

"Yep. About half a page."

"I thought the *National Enquirer* was a tabloid."

"It is," Mrs. Clark said. "Just as trashy as trash can be. I don't care for it myself but Patricia takes it. I'll show it to you when you get here. Congratulations," she said again. And she meant it. There was not a hint of sarcasm or judgment in Mrs. Clark's voice.

My literary career hadn't exactly been going swimmingly,

at least not according to me. When *Life Without Water*, my first book, was published, I thought I'd be quitting housecleaning, and when my second book, *Home Across the Road*, was published, I thought surely that would do it. But instead I seemed to be locked into the trade more and more with every book I wrote. The problem was that I couldn't write fast enough. I couldn't follow one successful book with another in the amount of time it takes to be forgotten. Writing this way would have been like having sex with one man after another. I would have hated it. But I wasn't exactly loving housecleaning either.

When I got to Mrs. Clark's, she already had the scissors out. The *National Enquirer* was sitting on the breakfast bar where we would be having our lunch and watching *The Price Is Right* in a few hours. Princess Di was on the cover. Mrs. Clark opened the newspaper and pointed to the article. I leaned in close, looking for the byline before I looked for anything else. I wanted to know who had done this to me. I immediately recognized the name. I'd given him a phone interview three months earlier. He'd told me he was writing a piece for a national women's magazine.

During the interview it came out that while writing my first book, I'd supported myself as a housecleaner. "What about your second book?" he asked. "What did you do then?"

"I had an advance," I said, "and I took a year off. But the money ran out. I did a few odd jobs and then started cleaning houses again. I'm still doing it."

I could feel the air on the other end of the line change.

"You still clean houses? You mean now?"

"I mean today. I'll be cleaning a house in just a few hours. I've already got my lunch packed."

I could hear him scribbling this down. He asked a few more questions and concluded the interview. The article should come out in a few months. August or September. He'd send me a tear sheet. Could he send a photographer over?

The photographer arrived a few weeks later. He set up lights in the little one-room cabin I shared with my husband and snapped pictures of me sitting at my old desk, pretending to write on my old Macintosh. He posed me outside too, sitting in the hammock, holding a copy of my second novel. These pictures were now in the *National Enquirer*.

The headline read "Here's One for the Books," and the subtitle read "Cleaning Lady Is an Acclaimed Author." The gist of it was that I worked as a "housemaid" and had two critically acclaimed novels and, according to the article, they loved me in New York. My husband Ben's name was given as Dan. And I was quoted as having said, "I'm just a regular gal who loves to write."

Now, I know I didn't say this. In my entire life I have never called myself either regular or a gal. But I guess it sounded housecleanerish, like something a common charwoman with two critically acclaimed novels just might say.

Before I'd even reached the dining room, Mrs. Clark had clipped the article and added it to her scrapbook. And as I cleaned the rest of the house, I tried to imagine what had derailed the article from the national women's magazine and instead placed it in the *Enquirer*. The only scenario that I could come up with was that the women's magazine had rejected the piece after they found out I was a housecleaner. And to save a little on his investment of time, the writer had pitched it and sold it to the tabloid.

It took me a while to adjust to being in the *Enquirer*. To my knowledge, no one was aware of it but Mrs. Clark and her daughter, my husband, "Dan," and me. But it was hard knowledge for me to carry. In line at the grocery store, I stared at the cover on the newsstand, at Princess Di's picture. I'd always flipped through the tabloids before but now I didn't.

Finally, a few days before it went off the stand, I bought a copy and read it through. I instantly felt better. I wasn't keeping such bad company after all. My teenage heartthrob Mickey Dolenz of the Monkees was mentioned, and a few pages before the "Here's One for the Books" piece there was an article about a man who'd chopped his girlfriend's head off and boiled it to make soup for the homeless.

"Don't get any ideas," I told "Dan."

2

DIARY OF A MAD HOUSECLEANER

Even before my first novel was published, most of my clients knew of my interest in writing. I preferred to keep it a secret, but sooner or later it always came out. A woman would be home one day and she would make polite conversation with me as I worked and she finished her coffee.

Was I married? Did I have children? How long had I been in the area? What were my interests—outside of housecleaning, that is? Writing? Writing what? And then the big, defining question: Are you published?

I longed to answer yes.

Answering no meant that I was just like everyone else, but

I was sure that yes would make me special. Yes would validate me. Yes would change my relationship to my family, anyone that had ever known me in school or otherwise, and all my clients. I would never be thought of as a mere laborer again. Just one book could do this forever. I was sure of it. Publishing would change everything, like winning the lottery. It both did and didn't.

On the positive side, my novels turned my writing into something real and solid, a book my clients could buy and read and put on the shelf for me to dust. On the negative side, it made me crazy to dust my own books. It's not that I didn't want my clients to read my books. I wanted everyone to read my books. It's just that I didn't want to clean my readers' houses. My books were supposed to deliver me from that work, if not the first novel, then at least the second one.

But they didn't. I was the novelist Nancy Peacock, who chased other people's pubic hair down drains. Some writers drink. Some use drugs. Some are verbally abusive to their students before sleeping with them. Cleaning houses was my vice. I was sure I was too smart for it, but I couldn't find a way out that pleased me. Housecleaning was the best job I ever had, given my propensity for solitude, working part-time, and a life without a boss. But it had its drawbacks. When I saw one of my books on a shelf as I moved through a house with a feather duster, my two worlds collided like a big bang that no one felt but me.

I remember one hard day. I was down on my knees, scrubbing my new client's kitchen floor while she sat on a barstool above me and asked me about my novels. I gave my usual plot summaries as I swabbed at a quarter-size circle of dried grape jelly. It wasn't an ideal time for me to be discussing my brilliant career. My back ached and all I wanted right then was for my client to go away and for that bit of grape jelly to loosen its hold on her linoleum.

Later on it got so that I didn't want to talk about my novels anywhere. When people I'd known for years stopped me in the grocery store to ask about my writing, I squirmed. I'd just finished cleaning a house. I was dirty and I smelled like bleach, and the questioner assumed a success which I could not pretend to under these conditions. I was sensitive on the subjects of writing and housecleaning. They prickled on my skin like an accidental spritz of Tilex.

One day a man I knew from my previous job as a baker in a pastry shop stopped me in the grocery store. "Oh, I remember you," he said. "You've written a couple of novels, haven't you?"

I put on my best PR face, slid my pocketbook in front of a bleach stain, hoped I didn't smell bad, and answered, "Yes, I have."

"Oh. That's very commendable," he said. "Of course I didn't like them much."

"That's okay," I told him. "You don't have to like them."

He looked at his shoes as if in great contemplation. "Tell me something," he said, looking back at me. "Why did I like *Bridget Jones's Diary* but I didn't like your books?"

"I'm sure I don't know," I answered.

I started moving away toward the bananas. For every step I took, he took one with me. I was starting to wish I did stink.

"There was something about that book," he said. "I liked it so much better than either of yours. Why is that?"

"I haven't read *Bridget Jones's Diary*, so I really can't comment."

"It was fabulous," he said. "You should read it. You might learn something."

And perhaps you should read Miss Manners, I wanted to say.

But what I did say was, "I need to go. It was nice seeing you again."

Perhaps I should have been rude. But he was an old man with a quavering voice, and since I'd gotten published I never knew when to be rude and when to be polite. It seemed like so much more was at stake now. After all, if I had been rude, he might not buy and dislike my third book, or my fourth. I had never expected publishing to cause such moral dilemmas.

I was more likely to have these sorts of encounters in the grocery store than anywhere else. People I barely knew stopped

to congratulate me on my novels and then, finding out that I still cleaned houses for a living, they showed overt dismay and genuine concern. The sympathy made me uneasy and the free advice I received just made me mad. I'd have more money than Oprah if I had a nickel for every person who suggested I write a book for her book club, as if Oprah ordered books like pizzas. Oddly enough, no one ever asked me why I didn't just knock out a Pulitzer Prize–winning novel. Perhaps they thought I was more capable of figuring out Oprah's tastes than what the Pulitzer committee might be looking for.

Plenty of people — my clients excluded — told me that I should quit cleaning houses. "Writing is more important," I was told. Usually the speaker said this very slowly, to make sure I got it. "You need to give it your all. Don't hold back."

I guess they thought I was conflicted. That I couldn't decide between being a writer or being a maid. But I wasn't holding back. In fact, it was the opposite, because I knew if I held back payment to the power company, they held back my electricity. It was the same with gas, phone, car insurance, and rent. Unfortunately, this was the arrangement I had made with all of them. I just hadn't known at the time that there were other options.

In my most logical moments, I knew I was doing the best I could. I knew that cleaning houses was a matter of practicality: paying my bills and not going into debt. But in my most

emotional moments, I knew that I was a failure. All I'd done was prove to the world that I could write a book and get it published. So what? I had yet to prove that I could make a living at this, and now that I had been published, it seemed like that was the only thing that would make me a real writer. I was depressed and I was angry. I didn't feel like a real writer, but I still pursued writing. And I still scanned the paper for literary events. And in the middle of this identity struggle, I went to a reading at a local bookstore.

The author was a mystery writer. I've never cared for mysteries and I wouldn't have been there at all, except that this one reportedly had a main character who was a housecleaner-turned-detective.

The room was full when I arrived but I found an empty chair in the center aisle at the far end. The writer was introduced and as soon as she opened her mouth, I regretted the loss of my Saturday morning. She pissed me off immediately.

The first thing she said was not to buy her book and then lend it out. And don't go looking for it in the library either, she warned. She didn't make any money that way and she wanted everyone who read it to pay for it.

If anyone in that audience understood her struggles, it was me, and yet I found this offensive and snobby. A lot of people, myself included, couldn't afford new books. I'd already been to

the reading of a Pulitzer Prize–winning author who suggested that unless we purchased hardback books, we were failing to support writers. I was tired of being criticized for using the library and buying the occasional paperback.

So, already I had my drawers in a twist when the mystery writer went on to tell us that she wrote her book partly because she'd had such difficulty finding a good housecleaner. She complained that the housecleaners she'd had in the past refused to move the refrigerator and dust behind it. Their husbands were always in jail and their cars always broke down and they needed rides. The audience tittered sympathetically and the writer continued. She wrote this book, she said, so that she could create the perfect housecleaner.

Then it was revealed that her main character wasn't a housecleaner-turned-detective at all, but was instead a detective who owned a housecleaning agency. I would never have come if I had known this.

I was itching to walk out of there, but I was seated in the middle of things, and having given a few readings myself, I was sensitive to the commotion I would make if I left. And somehow I kept my mouth shut during the question-and-answer period, although I longed to tell this author that asking a housecleaner to move the refrigerator was ridiculous, and that not all of us had husbands in jail, and yes, our cars do break down—as all cars do from time to time. The library, I wanted to tell her, is a

really, really good thing for all of us, but especially for people without a lot of money. I could feel my arm practically rising on its own, so I sat on my hands.

Finally the reading was concluded and the writer went downstairs to sign the books we were supposed to buy but never lend out. The audience filed out behind her. As soon as I could make a break for the door, I did. Outside it was sunny and warm but I was still fuming. Maybe I wouldn't have been so sensitive if I hadn't had to return to housecleaning after the year I took to actually live the writer's life.

That year was made possible by going under contract for my second novel. The partial advance I received was just enough to support me for a while. I'd always wanted to know what the writer's life was really like, and if I lived frugally enough I could quit my housecleaning jobs and be just a writer. It sounded so enchanting.

I lived alone at the time. It was a terrible winter. It rained nearly every day. The rain was deafening on the tin roof of my cabin and I had nothing else to focus on but the novel that was driving me crazy.

My characters kept trying out new names mid-manuscript. They insisted on personalities that I had not planned for them. And they loved to tromp down tributaries that were fascinating but not essential.

Each one of my first three drafts read like a first draft. None

of them got me any closer to the story. This writing-life thing wasn't going well at all, and every afternoon, rain or shine, I stopped writing and drove into town for a cheap meal.

I could have cooked at home for less, but after being alone all day, listening to the rain on the roof, wrestling with my prose and getting knocked over the head and left for dead by my characters, I needed to get out. I needed to be surrounded by real people, people whom I knew I didn't control. I needed this even if it only meant sitting at a table alone, eating and eavesdropping.

Toward the end of my year spent living the writing life, I received a phone call from a young writer who wanted my thoughts on something. He'd saved enough money to quit his job and support himself for a year. He wanted to write his book. He wanted to know if I thought, working full-time on it, he could finish it in a year. I told him I thought he could, but maybe he shouldn't just up and quit his job like that.

"Why not?" he asked.

"Because it's too much pressure," I said. "It's hard going from working full-time to writing full-time. Besides, I'm not even sure that writing full-time is such a good idea."

I couldn't believe I was saying this. I hadn't known I felt this way. I didn't miss housecleaning per se, but I did miss having something in my life besides writing. Writing had not become a strong enough foundation yet, and without the foundation of

regular work I felt like an emotional mudslide. I was caving in on myself. Living alone, probing a fictional world for six hours a day, was making me feel a little weird. This wasn't the way it was supposed to be.

I was discovering, in fact, that writing full-time was inefficient. I found that I could only write effectively for two or three hours each day. After that, time spent at the desk was time spent mucking up my characters' story. I'd lost my ability to listen to them.

"Work part-time," I told the young writer on the phone. "Stretch one year out to two. You'll still have time for two or three hours at your desk each day."

"But I really want to get this done," he said.

"You will," I told him. "You'll get it done."

Not long after this conversation my money ran out. I was due another portion of my advance when I delivered the manuscript, but I was far from being finished. My characters were still misbehaving, or maybe I was the one misbehaving. Whoever it was, I knew I didn't have a completed novel and I knew I had to return to work.

I placed my usual ad in the newspaper, using all my usual catchwords: "Mature. Reliable. Thorough. Honest. Ten years in the business." I skipped over the fact that writing had made me a little flaky.

I landed clients and filled my calendar and dug out my

gear. I took my vacuum cleaner head to the shop to have it cleaned. I washed out my carryall and filled it with products. I dug out the old restaurant napkins that I'd purchased from a laundry and used as rags. I replaced the lamb's wool duster and the feather duster and the head of my mop. And I bought an extra pair of rubber gloves in case I had a midday blowout. I was in the housecleaning business again. And after I returned to work, something happened to my writing. It got easier.

I worked part-time now. Only one house a day. I spent hours at my desk in the morning, before going to work. And once I was at work, once my body and conscious mind were engaged in the business of physical labor, my unconscious mind had the freedom to kick into gear. When I returned to the desk the next morning, my characters were friendlier. They weren't soft and fluffy, but I wasn't struggling with them so much either. Instead I was listening to them. I was willing to let them be themselves and tell me the story. I wasn't the writer anymore. I was the receiver.

3

BEDSIDE STORY

I think there are two things writers love more than anything else. One is solitude and the other is gossip. In the housecleaning trade I got both, but in all the jobs I worked before housecleaning there was too much gossip and not enough solitude. These jobs exhausted me. They strung my life together with days that lacked perspective and reflection. In the pie slice called work, where I spent most of my days, I needed solitude.

Earning a living has always been a question of what sort of job I could or could not wedge myself into. On this I think we are all equals. Some people are able to find their wedge early in

life. And some people just accept the wedges they were raised to fill, without question. Others find well-paying wedges and, while they may not like it, they stay because the money keeps them there. But for most of the creative people I know, earning a living has always been a problem.

Over the years, I have been employed as a baker, a milker on a dairy farm, and a clerk—in a drugstore, a hardware store, and a grocery store. I've also worked as a locksmith, a carpenter, a costumer, an assistant drum-maker, and a bartender. Bartending was long on gossip, but short on solitude.

After finding out that I wanted to be a writer, the men I served at the bar—and they were mostly men—suggested that I write a book about my experiences working there. I joked that I would title it *Four Years Behind Bars*. I never told them that I thought it would be a boring subject. After a while, the stories I heard as a bartender became repetitive, sort of like the country-and-western drama that played on the jukebox. Besides, even though I held on to that job longer than any other, until I became a housecleaner, I was never able to write while working as a bartender. It was too much of a social job. Housecleaning offered me the peace and quiet I needed to actually move from wannabe to writer.

Mostly I was alone in the houses I cleaned. Given a choice I always preferred it this way. If my clients were home the best I could hope for was that they would stay out of my way, and fail-

ing that, I hoped they had a good story to tell me. The Brogan house started off with solitude.

Donna and Mike Brogan and their son, Trevor, lived in a nice house on a lake. Everything inside was white. White walls, white carpet, white couch, white table, white chairs, white tiled floor, and white appliances lined up like soldiers on the white Formica counter in the kitchen. I'd cleaned all-white houses before. Mostly they belonged to therapists, but neither Donna nor Mike was á therapist. She was a secretary and he was a lawyer. They checked out my references and hired me for Thursday, every other week. They gave me a key and said they'd leave the check on the table. This was just what I had hoped for.

There were only two minor annoyances with my new house. The first was that Donna insisted I vacuum the fuzz of lint behind the dryer, and this involved climbing up on it and poking the wand between it and the wall. And the second was that in a moment of weakness I'd agreed to change and launder the sheets on the beds.

When I first started out in housecleaning, I did beds all the time. It was a part of my package. But I quickly learned that beds are both time-consuming and backbreaking. All that bending over and tucking sheets in. Three beds a house, two houses a day, five days a week. That added up to thirty beds a week. Besides eating up my hourly wage, the beds were clearly going to kill me.

I also learned that people are funny about their beds. One woman was obsessed with folding the covers down just right, seamlessly matching the paisleys of the bottom sheet to the paisleys of the comforter like a good wallpapering job. Another woman had a stack of twelve sheet sets in her bathroom closet, and even though they were all made for a queen-size bed, not all of them fit. Some were too small. I guess they shrank in the dryer, and when I put the bottom sheet on, it seemed like the mattress was going to curl up at the corners and pop the sheet loose like a rubber band. I wasn't about to fold it up and try another set. It, too, might not fit, so I jerked the sheet on as best I could. One day my client with the too-small sheets brought the whole sordid subject out into the open.

"Oh, Nancy," she said as soon as I walked in the door. "The sheet you put on our bed last time was too small. It was coming off the mattress all week long. The ones with the little yellow flowers fit but the ones with the little blue flowers are too small. The red ones are too small, the green ones are too small, the beige ones fit, the blue ones are too small, the sort of lacy-patterned ones fit, but the other lacy-patterned ones don't fit. The pastel yellow ones do and the bright yellow ones do but the creamy-colored ones don't," she said, by way of explanation. You can see why I preferred clients who were never home.

"I tell you what," I said. "Why don't you just put out a set of sheets for me every week."

"Well, it's really quite simple," she said with a sniff.

"Just set them out on the bed and I'll do the rest," I answered with as little inflection as I could muster. The sheets had been pissing me off for a long time and I wanted to scream the obvious: Get rid of the fucking sheets that don't fit. What's the point of keeping them? Are you crazy? Clearly she was, but it wasn't my place to run the household. It was just my place to deal with it.

As beds go, Donna and Mike's were pretty easy. The sheets always fit. There were only two sets for each bed, the set that was on the bed and the one stored in the linen closet in the hallway. It was a simple, functional, admirable system and I was extremely grateful for it.

As soon as I arrived, I stripped the beds and started the laundry. Then I got the new sheets from the closet and remade the beds. Donna wasn't particular about folding the sheets down or which pillows went in front or back. Everything was white and there weren't a lot of options.

As soon as I finished with the beds, I cleaned the kitchen. There was a small white television on the counter next to the coffeemaker. It took me twenty minutes to do that particular kitchen, and *I Love Lucy* was always on during that time. I half-watched *Lucy* while I cleaned. When I was done in the kitchen I clicked the TV off. The house was silent except for the washing machine rhythmically sloshing the sheets.

I moved to the back of the house and did the bedrooms, the two bathrooms, and the hallway. The last things I did before lunch were climb up on the dryer and poke my vacuum cleaner wand into the lint and then switch the sheets from the washer to the dryer.

I sat in one of the white chairs at the white table, unzipped my soft cooler, and ate while looking out over the lake. I often saw a red-tailed hawk careening above the pine trees. After lunch I cleaned the home office, then dusted and vacuumed the living room, and replaced the rugs on the floors I'd mopped. My last task was folding the sheets and putting them away. Donna and Mike's house was serene, the solitude predictable. I always knew what to expect. There were never any curveballs. It was simple. Come in and clean and leave. The check was always on the table.

But one day I came driving up to the house on the lake and Donna's car was in the driveway. Shit, I thought. I hope she's leaving. I parked and hauled my gear out of the truck, set it on the front porch, and opened the door. Donna was sitting in one of the white chairs at the white table, wearing a white bathrobe and drinking a white mug of black coffee.

"Hi," I said.

"Oh, Nancy. I forgot you were coming." She ran a hand through her hair. "Do you mind if I'm here for a while?"

"No," I lied. "Of course not." Donna's eyes were puffy. Her

hair was bad hair. She hadn't put her makeup on yet. "Are you okay?" I asked.

She sighed. "Why don't you sit down and have a cup of coffee with me. There are some things you should know."

"Okay."

I was sure I was getting the axe. I tried to think of why. Had I left something undone? Had I left sheets in the dryer or, even worse, in the wash?

Donna got up and pulled a mug out of the cabinet. She poured me a cup of coffee. "Cream or sugar?" she asked.

"Cream," I said.

She pulled a carton of half-and-half out of the refrigerator and a small white pitcher from the cabinet. She filled it with cream and brought it to the table. I fixed my coffee while she pulled her robe tighter and sat down and then stood up again to get me a spoon.

"Mike and I are getting a divorce," she announced, settling into her chair again.

"I'm sorry to hear that," I answered.

I poured cream in my coffee and thought: Divorce. I was definitely getting the axe. I tried to remember if I had anyone on my waiting list or not. I wondered if Donna would give me notice or if this was my last time in the all-white house on the shores of the lake. Mike would probably be moving out and Donna would be staying in the house. I was about to become

an unnecessary expense. A luxury. I was relieved it didn't have anything to do with my work. I could count on Donna to give me a good reference. I took a sip of coffee and waited for the inevitable.

"Mike's having an affair," Donna blurted.

"Oh, I'm sorry. That must be very painful."

It was starting to appear that this had nothing to do with me. I was not going to get fired after all, and as long as I wasn't going to get fired and I had a cup of coffee in front of me, and Donna was in a talkative mood, I might as well go into my junior therapist routine.

"Did he tell you about it?"

Donna shook her head. "I hired a detective."

Whoa! This was going to be a good piece of gossip. This was going to be worth losing a little housecleaning time.

"You had him followed?" I asked.

She nodded again. "I was suspicious. He wasn't home much and when I asked him about it he said he was just working. I asked him point-blank if he was having an affair and he said I was being paranoid. So I had him followed. She's a cocktail waitress. Can you believe that? Mike doesn't even know about this yet. I just found out an hour ago and I called in sick. I couldn't go to work," Donna said, rubbing her face. "You don't mind, I hope."

"No. Of course not."

"I'm going out in an hour." She looked at her watch. "I'm meeting the detective. He has pictures. I have to pay extra for the pictures. Did you know that?"

I didn't know that but it struck me as interesting. I slipped it into my mental file of tidbits. Maybe I could slide it into a story later, although I hadn't written one yet with a detective in it. But that didn't keep me from picturing one waving a closed manila envelope in the air above his messy desk, waiting for Donna to write a check. Or maybe it was done clinically, through his secretary, leaving her to pass the dirty, awful envelope to Donna, his job being the more exciting end of it. Tracking wayward husbands and taking pictures with a tiny tie-clasp camera. That thought caused me to wonder exactly how he had pulled this off. Did he have a van parked outside the bar, equipped with bags of doughnuts and Styrofoam cups of coffee? What kind of camera did he use? How much did he charge? These were the details that I wanted. I couldn't help myself. Writers thrive on the minutiae of life and I was no different. I didn't want the dirt of Mike's affair as much as I wanted to know how Donna had chosen the detective, what he looked like, how he'd pulled his caper, and what kind of cigarettes he smoked. Compared to this, Mike's affair seemed predictable. But it hadn't been predictable to Donna and she was still sitting across from me, hurting and finally having someone to talk to.

"He always comes on my stomach," she said. "He never

comes inside me. He pulls out and comes on my stomach. Now what's that about?"

I heard my chair scrape across the tile before I even knew that I was getting up. This was more than I wanted to know. I looked at my watch. "Oh. I better get started. Time's a-wasting. Thank you for the coffee." Donna nodded and put her head in her hands. I carried my mug to the sink and ran water in it.

"I'm sorry for your troubles, Donna," I said. I really meant it. I felt bad that she'd told me so much. She'd regret it later, I thought.

"Thank you," Donna said. She got up and carried her mug to the sink. "Do you mind if I take a shower? I won't use the master bath."

"No. Go ahead."

I went to the bedroom to change the sheets, but as I tugged on the bedspread, Mike and Donna's sex life crossed my mind. I got my rubber gloves out of my kit and wore them while I stripped the beds and shoved the sheets into the washer. I heard the water running as Donna took her shower. I decided not to start the washer until she was finished. The last thing Donna needed today was to get scalded by the maid.

By the time I'd gotten the beds made up with fresh sheets, the shower had cut off and I could hear her moving around in the bathroom. I punched the buttons on the washing machine and then went to the kitchen. Donna came in fully dressed.

"How do I look?" she asked.

"Good."

"I feel like shit."

"You look good." I rinsed out the coffee mugs and added them to the dishwasher, then spritzed the sink and started scrubbing. Donna sat at the table and plowed through her pocketbook, pulling out her checkbook. She wrote one out and tore it off, waving it in the air to show to me before sliding it under the pepper grinder.

"Wish me luck," she said.

I watched from the kitchen window as she backed her car down the driveway. Before she'd even reached the end, I turned on the tiny television on the kitchen counter. But *I Love Lucy* was over. *Green Acres* was on. I hate *Green Acres*. I clicked the TV off. The sheets sloshed in the washing machine. I looked out the window and saw the red-tailed hawk, careening among the tops of the pines. I was grateful for the solitude.

4

TRICKLE-DOWN ECONOMICS

I hated the Krueger job. They were on what I called my hit list. As soon as I was offered another house I would drop them.

The Kruegers were retired, so except for a few long weekend trips to their lake house and a smattering of doctor appointments, they were always home, and if they were home they were underfoot. Mr. Krueger loved to sit in his chair dropping his newspaper to the floor. And Mrs. Krueger loved to follow me around making requests as I cleaned.

"Could you just run your vacuum up the inside of the drapes? I saw a spider crawl out of there the other night."

"Could you mop extra-well in the back bathroom? I spilled a little powder back there."

"Could you dust these silk flowers? They're getting a little dim."

Once, when she was unable to do this because of an early dental appointment, she mined the path of my cleaning day with yellow sticky notes. On a desk, "Polish this." On a mirror, "Clean this." On a chair, "Dust the rungs and turn the cushions." On the refrigerator, "Wipe the fingerprints off." On the framing of the screened-in porch, "Bleach these all the way around."

The Kruegers also needed heavy lifting from me, lifting that was not in my job description and for which I was never offered any extra money. At first I helped with the lifting. They were old, after all. But soon it became apparent that there would always be lifting. It would never end, because the Kruegers loved to shift and rearrange and, more than that, they loved to ask me for things.

I was asked to hold a mirror above the mantel while Mrs. Krueger stood back and looked, tilting her head this way and that. I was asked to move bookcases and armchairs, and to shift a desk three inches to the right, oops, a little too far. Every day that I cleaned the Krueger house time ticked away, unpaid. And every day that I left the Krueger house I left seething. It was the potted ficus tree on which I finally drew the line with them.

Mrs. Krueger thought it would look better in front of another window. Could I just move it over there? So she could see how it looked.

"No," I said. "I can't do that."

They looked at me blankly.

"My back," I told them.

"Maybe you could shove a towel under it," Mrs. Krueger offered helpfully. "That might make it easier."

"That's a heavy pot," I said. "I have a bad back and I can't help you. I'm sorry."

I pulled on my rubber gloves, squirted the sink with cleanser, and began scrubbing.

I heard Mr. Krueger blow a loud blast of air out of his lungs. "You're in the wrong business," he said.

I could have told him that I wasn't in the moving business. Instead I said, "I know. But I can't help that. I need to take care of my back so I can keep working."

This was not a lie. Housecleaning was hard work and moving things for the Kruegers put my back at risk and I needed my back. Where would I be without it? Besides, I knew their son lived a few miles away. Let him move things and hold up mirrors. I had a house to clean.

The Kruegers stood staring at the ficus tree and then at me while I rinsed the sink and began cleaning the counters. Finally Mrs. Krueger shrugged and said to Mr. Krueger, "Are your

clothes in the hamper? If there's anything you want washed you better let me know now." They trundled off to the bedroom and I heard the washing machine start up. By the time I'd finished the kitchen, they were walking around the yard, pointing at the garbage cans and the azalea bushes.

The Kruegers left to go shopping that day. I was down on my knees swabbing the jets in the extra-large tub when Mrs. Krueger poked her head in the door and said, "Your check's on the counter. Just lock up when you leave." She grinned at me like a little girl. I smiled back and thanked her. I was relieved that the whole potted-plant issue was behind us now. I finished up the bathrooms, mopped the floors, and went into the kitchen to wash my hands and get a drink of water.

The little blue rectangle of check was next to the sink. But it wasn't alone. It sat on top of a note and a bumper sticker. The note read, "Nancy, we thought you might like to put this on your truck." And the bumper sticker read, "Say No to Four More Years of Hillary."

"Oh, fuck you," I said into the empty house. "What more do you want from me?"

I'd really had it with these people. Already I scrubbed their toilets, picked up his paper, plowed through her constant editing of my work, and dusted their collection of elephants lined up next to the signed picture of Ronald Reagan. Furthermore, I had done heavy lifting without compensation and never once

discussed politics with the Kruegers. They knew nothing about me except that I drove an old truck, I cleaned their house, I had two published novels, and I had finally refused to move something, all of which, I suppose, made me a Democrat.

I muttered under my breath as I leaned down and picked up the dried fallen leaves from the ficus tree. I grumbled as I ran the vacuum over the Persian carpets. I gave Ronald Reagan and the elephants a flip with the duster and fantasized about leaving the bumper sticker floating in the toilet. But at the end of the day, when my work was done, all I did was leave the bumper sticker behind, along with a note that said, "I like Hillary." And then, remembering that the next time I was scheduled to clean the Krueger house was a holiday, I added to the note: "I am scheduled to clean two weeks from now on Martin Luther King Day. I just want you to know that I am working and plan to be here. See you then." I locked the door and left.

I felt much better inside my truck. Better still once the golf course was behind me. And even better than that after I'd passed the guardhouse of their gated community and emerged into the real world. I thought that I had handled the situation pretty well, not showing my fury but at the same time leaving the bumper sticker behind and taking my self-respect with me. But even so, the Kruegers and their potted ficus tree mixed in my mind like Clorox and ammonia. More than usual, the

Kruegers were poisoning my spirit, and the day would require some processing on paper.

I drove to my favorite café and treated myself to a milkshake. Sitting on the little couch in the corner, I opened my journal and began writing. This is how I process everything, and I believe my journal, more than anything else, has made a writer of me. I believe that just the act of writing, of processing on paper and recording my truth, has eased me into the acceptance of vulnerability. Writing is a vulnerable act and each day truly is a risk.

On the day that I refused to move the ficus tree for the Kruegers, I risked my job, but usually the risks of a day are much subtler. Most of us risk our whole lives and our integrity with the jobs we work. We do things we don't like and don't believe in so we can have a paycheck. I don't exactly believe in housecleaning. Mostly I think people should take care of their own stuff, but housecleaning supported writing, so I did it.

I used to look at the masses of people, going to and from work, with envy and even awe. How wonderful, I thought, to know with such absolute precision your exact path. But I have talked with enough people now to know that most of us don't know our exact paths. Most of us long for something deeper than going to work and coming home. Writing can help. Even if you don't long for publication, just the act of exploring yourself can take you deeper and deeper into your soul.

Over the years my journal morphed from mostly self-absorbed schlock, which I could barely stand to look at later, to more self-absorbed schlock and a few pages of essays and story ideas and observations of what I see and hear in the world. My journal is a writer's notebook now and as soon as I fill one, I mine it for any ideas I might want to develop into a story. But more important, my writer's notebook is a place where I can be myself without judgment.

On the day I refused to move the Krueger's ficus tree, I spilled into my journal all the fear I'd felt over spurning their request. I knew I was changing the dynamics of our arrangement and that the result could be a loss of income. What I didn't see until I wrote it out was that I'd won the battle. The gift of the right-wing bumper sticker was a jab, the only power they could come up with. I knew and they knew that I wouldn't be providing them with free labor any longer. But I would still have to pick up Mr. Krueger's dropped newspapers and navigate Mrs. Krueger's neediness. They remained on my hit list.

In the café that day I closed my journal and slurped the last of my milkshake and thanked God that I wouldn't be seeing them again for another two weeks. But of course two weeks rolled around soon enough.

I woke up tired. I'd had one of my housecleaning dreams the night before. They were worse than an actual workday. A

workday had an end to it, but my housecleaning dreams were an eternal loop of scrubbing and vacuuming and dusting and mopping. Just as I thought I was done with my "dream house," I'd notice something I'd left undone and then something else and something else and something else so that in my dream I never quit cleaning. When I woke up, even my body was tired.

I wracked my brain for what day it was. Monday. Which Monday? Martin Luther King Day. Which house? Oh, God. The Kruegers. I hoped they'd taken the holiday and gone to their lake house but when I got there and called hello as I opened the door, I heard Mrs. Krueger sing her hello back to me.

Mr. Krueger was sitting in his armchair, wearing a robe. His feet were clad in leather slippers and propped on the ottoman in front of him. He was smoking his pipe and he peered over the edge of his newspaper to say hello to me. I noticed behind him that the ficus tree had been moved.

Mrs. Krueger was fussing around as always. She opened a drawer in the kitchen and asked me to clean it. She pointed out fingerprints on the stainless-steel refrigerator. Then she crooked her finger and motioned for me to follow her into the bedroom, where she pulled the drapes back and pointed to the floor. "Could you use your magic little vacuum cleaner thingy to get the dirt there?"

I knelt down. "Here?" I asked, wedging my finger between the carpet and the baseboard.

"Yes. There," Mrs. Krueger said.

Just then the doorbell rang and she rushed off to get it. I rushed off to start cleaning, hoping that our tutorial was over. I was in the kitchen pulling on my rubber gloves when she returned. She had a card in her hands. It was shaped like a large martini glass. "That was the most creative individual," she cooed.

Mr. Krueger lowered his paper and squinted at her over his glasses.

"It was our new neighbor." She wagged the card in the air. "And she's having a martini party for Martin Luther King Day. Do you get it?" she asked. "Martin and martini."

I ducked my head, stifled a laugh, and rinsed the sink.

"Do you want to go?" Mr. Krueger asked.

"I think we ought to, don't you?"

"What time is it?"

"Three," Mrs. Krueger answered. "I just can't get over how clever that is." She opened the card and then held it to her bosom. "Martin and martini." She chuckled and looked at the card again. "Now Nancy, you did hear what I said about vacuuming in the bedroom?"

"Yes, ma'am. I heard."

"Martin and martini," Mrs. Krueger said again. "I wish I could think like that but I just don't have a creative bone in my body. Now, Nancy." She turned to me again. "You're lucky. You're creative."

"I am lucky," I agreed, spritzing the countertop with 409.

5

THE PROMISED LAND

I cleaned one other house in the gated community. It belonged to the Coopers, and I did not hate it or dread it the way that I hated and dreaded a day with the Kruegers. What I did hate and dread was the drive through the gated community. It was called Chancellor's Estate and it was built on the northernmost edge of a county with the lowest property taxes around. I called it the Promised Land.

I used to live just through the woods from the Promised Land, along a dead-end dirt road that's still there. I passed the dirt road on my way to the gated community. I passed trailers and farmhouses, too. But the closer I got to the Promised Land

the more the landscape changed. It was nothing like it used to be. Where there had once been fields with cows, there was now a shopping center with a grocery store and a bank.

I puzzled over the purpose of a gated community every time I went there. Were the gate and the guard meant for show and prestige? Or were the gate and the guard a serious attempt at protection? And protection from what? Terrorists? Jehovah's Witnesses? Political canvassing? Common, low-income riff-raff? There was plenty of time to reflect on these questions as I waited in line at the gate with the rest of the common, low-income riffraff.

We queued up at eight a.m., a long line of service workers. There were vans with ladders on top, trucks pulling trailers loaded with slabs of sod, flatbeds full of lumber and bricks, and empty dump trucks ready to haul out dirt or any other unpleasantness. There were also the maids. Little blue Molly Maid cars full of blue-uniformed Spanish-speaking women. And big station wagons with vacuum cleaners and mops and buckets tossed in the back. And there was me in my truck with the bumper sticker that read, "Metaphors Be With You."

Every one of us had to be screened at the gate by the guard. He wore a blue blazer with the gold Chancellor's Estate insignia sewn to the breast. He had a world of responsibility on his shoulders. He had to judge us. He had to make sure that everyone he admitted to the Promised Land was a safe bet, that

none of us were rapists or murderers or terrorists or, worst of all, thieves. There would be hell to pay if anything went missing inside the gates of the Promised Land.

But there would also be hell to pay if the guard did not let me in to clean. This was mostly a problem if I had agreed to extra work, or my schedule was jumbled due to a holiday or a client's vacation. In cases such as these I always left a note for my client, reminding her to let the gatekeeper know of the change. But after a couple of close calls, in which my client neglected to alert the guard of the change and I had to talk my way in, I started making a follow-up call. I had to time my call just before my scheduled workday. Too early and it would be forgotten again. Too late and the client might be out of town. This meant that I had to keep track of my client's schedule as well as my own. I resented this secretarial work as much as I resented a toilet left unflushed.

I couldn't understand why anyone would choose to live in a gated community and then forget to call the guardhouse every time their life required another person. Or why, for that matter, anyone chose to live there at all? To me the Promised Land was over-the-top, a hoax, show-offy and tacky, like having a breast enlargement when you were already a size double-D.

While I waited in line at the gate, the residents of the Promised Land whizzed by me to the right, their own special gate flying open as they approached. To my left they exited the

Promised Land, heading off to offices and boardrooms and gro-
cery stores and lunches. I know that many of the people of the
Promised Land worked hard. I'm sure they worked harder than
I did, which gave me something else to ponder as the line crept
forward. Why didn't I work that hard? What has kept me out of
the nine-to-five? What inside of me has been in constant rebel-
lion against the long hours of school and regular work?

I could say it was writing. But that's not really the answer.
The answer has more to do with my temperament, and my in-
ability to sit still for long periods of time. I've never wanted to
use my body in the disciplined way of an athlete, but I've always
needed to move. And I've always loved my imagination. And
these two things, moving my body and using my intuitive imag-
ination, have always worked best together. In this way, being a
housecleaner and a writer has been a good marriage.

If I could be left alone in a house, if all I had to do was clean
it, my mind could wander wherever it needed to go. Before I
started writing every day, my mind wandered too far. It roamed
from hill to hill, never stopping for the view. Writing reined it
in and gave it a path, but it was still free to roam.

Often writing is not thinking, it's noticing. And by working a
job that allowed me to use my body and be in solitude and quiet,
I had opened my life up to noticing. I never planned it that way.
It just happened. I was sure that I would earn enough money
from my writing to live in the Promised Land if I wanted to, but

I wouldn't want to. Instead I would buy a mountain and become a recluse. Maybe even get weird, like Howard Hughes.

Fortunately, I was saved from that. Not so fortunately, there was plenty of time to reflect and be humble as I waited for admission into the Promised Land. Up ahead, the gatekeeper stepped inside the guardhouse. I was six cars back now and I could see him through the window with the telephone receiver pressed against his ear. He hung up the phone and stepped back out carrying a Xeroxed map. He showed it to the driver of a van with ladders strapped to the top. The guard pulled his pen from the pocket of his blazer and pointed to the snake of roads on the paper. He drew a mark along one and handed it to the driver, clicked the remote control in his hand, and the gate rose. The van with the ladders was admitted.

The guard took his time with us. It did not matter to him how many vans and trucks and Molly Maid cars queued up. He would not be rushed. There was no need to rush. If we were late for work, we would be blamed. If something went wrong beyond the gates, he would be blamed. And besides, this was a classy operation and in a classy operation one never hurries for the little people.

Finally it was my turn. He could never remember my schedule. It might have had something to do with its irregularity. I cleaned the Krueger house every other week, but I cleaned the Coopers only once a month.

"Cleaning the Cooper house," I said to the guard.

"I thought you did the Krueger house," he said.

"I do both."

"Cooper. Cooper. Cooper," he mulled. "The Coopers on Lake View?"

"No, the Coopers . . . oh hell, what's the name of that road? I don't know the name of the road. I just know how to get there. It's the Richard Coopers. Wife's name is Lee Ann. Son named William. Dog named Scooter. He's in college. The son, I mean. You know, you go down the main drag here and turn left at the pool. And then right after you go over the lake."

"Uh-huh. You do that weekly?"

I shook my head. "Monthly."

"Not weekly?"

"Monthly."

"How's the weather down your way?" he suddenly asked. "Did you get any rain?"

The guard started a conversation about the weather every time. At first I didn't understand it. He didn't even know where "down my way" was. But he was the gatekeeper. If I wanted to work that day, I had better answer his questions, no matter how inane they seemed or how much they ticked away my time. Later I came to realize he was just stalling, giving himself space to think while I rattled on about rain or lack of rain.

"No rain yet," I answered.

"Uh-huh. We got a few inches in Siler City. Needed it too."

"That's good. I wish we'd get some. The plants sure could use it. My husband's watering the garden every night when he comes home from work."

"Have a good day," he said suddenly. He pressed the remote control in his hand and the gate lifted. He must have decided I was all right, a safe bet, worthy of entering the Promised Land and cleaning a few toilets. Praise Jesus and hallelujah.

My annoyances weren't over yet though. At the top of the hill another huge house was being built and I had to wait for a cement truck to back in. While waiting, I wondered, and not on a professional level, how many bathrooms were in this house and for how many people. I'd heard a story about a house in the Promised Land that had seven bathrooms for two people. Then the husband died during construction and she moved in alone. Seven bathrooms for one person. How unhappy could that make you? Just stocking seven bathrooms with toilet paper would put me in the hole, so to speak.

Bathrooms seemed to be a big issue in the Promised Land. As I drove past the construction site I noticed that the blue Porta John set up for the workers had a lattice frame built around it, so the occupants of the Promised Land wouldn't have to see it on their way in or out. I laughed out loud over this and filed it away in my mind as a detail I might use in a story somewhere.

But it wasn't likely that I would write a story with a gated community as a setting.

The golf course flanked both sides of the road and I had to wait once more, this time while a little electric cart crossed in front of me. Along one hill of the golf course was a medallion of boxwood bushes trimmed to create the initials "CE" in fancy boxwood script. They were dying.

I passed a pond and looked for turtles. Then I passed houses with five-car garages and circular driveways and more boxwood bushes whipped into submission by Mexicans with hedge trimmers. Other brown-skinned men were blowing leaves away from the green carpet of lawn. One rode a mower back and forth. Another was sawing the limbs of a crepe myrtle down to an unnatural skeleton. Farther down the road a different swarm of workers were laying sod on the bare grounds of a just-completed starter mansion.

I still had the health club to get past and the pool, the lake to cross and more big houses. I was not jealous of this wealth. I was not envious. I did not want it for myself. Nor could I keep from feeling appalled.

On one boring vacuuming trip into Mrs. Cooper's closet I amused myself by counting her shoes. She had 44 pairs. Mr. Cooper had 23. Since I am always collecting details and noticing things for my writing, I called this research. After counting the Coopers' shoes I started counting other things

in other closets. One client had 363 shirts and another had 25 pocketbooks. Then I started counting shampoo bottles and makeup. I couldn't stop myself. I moved on to cologne, towels, the number of pillows propped on a bed, the number of televisions and phones in a house, the number of silver candlesticks displayed in a dining room. It made me angry that there was so much stuff in these houses, yet most of them did not have even one decent broom.

As I worked and sometimes counted things, I thought about walls and gates. I'd read in one of my writing books that it was necessary not to suppress our feelings. I'd read that when we suppressed our feelings, when we lived false lives, our writing would suffer for it. We would not be able to open ourselves up to the possibilities. But most of all, we would not be able to feel empathy for other people and therefore for our characters. I knew I had a problem feeling empathy for the people in the Promised Land. I knew that money didn't solve all their problems any more than it would solve all mine, but I couldn't get beyond it. I couldn't see past the glitter.

Once, while on book tour for *Life Without Water*, I was picked up from the airport in a limousine. How does one act in a limo? I didn't know. It had wheels. It would get me to my hotel. That much made me happy; the rest of it just seemed silly. And I worked like a trained monkey for that limo ride.

There was a dinner, a dessert party, drinks at the bar, a reading, an interview, another reading, signing books, and then the grand-finale dinner, where everyone around me got so fucking drunk I couldn't believe it. I hadn't seen that kind of drunkenness since I worked as a bartender in a honky-tonk and broke up fights. I was shocked. I hadn't expected teetotaling but I hadn't expected knee-walking either.

The day I was scheduled to leave, there was no limousine or van or cab or anything provided for my trip back to the airport. The irony was not lost on me. The show was over. Personally, I would have preferred a less expensive vehicle picking me up from the airport and another less expensive vehicle for the trip back. But practicality was never the issue.

I had the same façade-like feeling in the Promised Land. I felt like everything could crumble any minute and that no gate or guard with a gold insignia on his blazer or lattice framework around a Porta John could keep out the vulnerability of being human.

I think that in the beginning of my writing life I believed that writing, publication in particular, could, besides making me rich, also make me invulnerable. It might have been the stupidest thought I ever had, because there is nothing, with the exception of love, that has ever made me feel more vulnerable than writing and publishing. Not housecleaning. Not

living from paycheck to paycheck. Not living without health insurance. And not waiting in line at the Promised Land for the guard to raise the magic gate. If anything, writing has finally taught me that there is no magic gate. And that all the walls we build, we build first inside ourselves.

6

THE GILDED AGES

The Ages house was a problem right off the bat. For one thing, Dr. Ages, recently retired and therefore home, was a prick. There is no other way to say it. He was a mean-spirited, tight power-tripper who used his money as a relationship tool. He also liked to take a poop and then leave it there for me.

His wife, Delayna, was twenty years his junior. She loved to tell me how much they had paid for things. Fortunately she was usually busy. She exercised constantly. Or else was off to have her hair done, or her brows, or her nails, or to get waxed.

When Delayna was home, she thought nothing of standing naked in front of the bathroom sink, washing her face with

the door open. And their two teenage children, one male, one female, regularly watched TV in their underwear while I vacuumed; or they stood, in similar attire, in front of the refrigerator, drinking from a carton of milk while I scrubbed the sink.

None of this was sexual, but I resented it. The message I received was that I didn't exist as a sexual being. I wasn't important enough to worry about. Being naked in front of the maid was the same as being naked in front of the dog. The dog didn't care, so why should I?

I could never think of a tactful way to broach this subject. As I endured these bouts of nudity and semi-nudity, I felt grateful to Dr. Ages for remaining clothed while I was there. He might not have been able to flush the toilet after a number two, but at least he knew how to pull his pants back up.

There were other bathroom-related problems, besides Dr. Ages. They had a dog, named Jack, who habitually lifted his leg and peed on the kitchen cabinets. Every time this happened, Delayna acted as if it had never happened before.

"Jack," she'd say. "What in the world has gotten into you? You know better than that." Then she'd toss a few paper towels onto the spreading pool of urine and lead Jack off to his crate.

In spite of the fact that I was left to clean up his mess, I always sided with Jack. All he needed was a walk or to be let outside. Instead he lived his life between the crate and the kitchen. Jack never noticed my empathy though, and he never warmed

up to me. He was a mean dog. He barked, growled, and bared his teeth, and even the Ageses, who normally did not care about my well-being, had warned me not to approach Jack.

At first I was confident that I could befriend him. I had befriended plenty of hostile dogs, and kept a box of Milk Bones in my truck just for the purpose. But Jack wouldn't touch a Milk Bone, even if I tossed it across the room.

Often, if the Ageses were gone, I would find Jack closed up in the kitchen, which I needed to clean. If Dr. Ages had remembered to pay me, which he often didn't, my check would be within sight but Jack would be standing between us, growling, drooling, ready to tear me limb from limb if I so much as set foot on the tile floor.

Over time I came to wish he'd die. No one took care of him. No one played with him. No one took him for walks. And I was tired of cleaning the sticky yellow drips off the sides of the kitchen cabinets. Some jobs you should just quit, and this was one of them.

The house itself was not too bad. It was all on one floor. Its worst feature, besides the Ageses themselves, was a sunken tub set in a platform in the master bedroom. The tub was so deep that I practically needed a wet suit and a snorkel to clean it.

The Ageses lived for show-and-tell. Everything was grand, including the piano, which no one in the household knew how to play. There were gleaming copper pots hanging from a rack

in the kitchen, but no one cooked. There was a huge cabinet full of Waterford crystal, which, Delayna had gone out of her way to tell me, cost $75 per glass. In Delayna's closet was a slinky black dress, which, according to my source, cost $800.

Worst of all was the way they treated their orchids. When the orchids in the living room quit blooming, they were moved to the bumper room and replaced by new orchids purchased in bloom. The orchids in the bumper room were left to die a slow death, withering away from lack of water. I would have liked to take them home with me before they died, but not one was ever offered. To offer the plants to me would be to admit that they were going to be killed, but admitting to horticultural genocide would have screwed with the Ageses' self-image just as much as having a plant that went out of bloom.

The Ageses' house was all about bloom, all about show, all mirrors, all display, right down to the Waterford crystal and the orchid exchange. Right down to Delayna telling the maid how much money she'd spent on all the dustable crap in her house. And right down to the literal crap that Dr. Ages refused to flush, as if his shit blooming in the toilet was decorative and something to be proud of.

Their daughter's bathtub drain was so horribly clogged that it was impossible to rinse clean. The water moved out of it at the pace of mud, too slow to take the grime with it, no matter how many times I filled a cup and rinsed. Eventually I would

give up on rinsing the tub, and would go to the kitchen and get paper towels to wipe it out with. Week after week I left a note on the counter, asking Dr. Ages to attend to this problem, but nothing was ever done. Finally I brought my own bottle of Drano and poured it into the clogged tub as soon as I got there.

Meanwhile new clothes appeared in all the closets, new fluffy towels appeared in all the bathrooms, and new feather beds in each bedroom. The next week, as I vacuumed, I noticed that no one had liked the feather beds, and each of them was now crammed onto the floors of the closets.

Except for the trash and garbage disposal, there was no outflow in the Ageses' house. There was only inflow. Floods of new clothes and shoes and impulse items poured into the household, but nothing was ever bagged up for Goodwill. No fashions were culled to make way for new fashions. Toiletry products accumulated along countertops and the edges of tubs and showers and sinks. The linen closet bulged with unused towels and sheets. And in the bumper room the orchid body count continued to rise. The only thing I ever saw them get rid of was the sisal rug in the kitchen, which, after years of Jack peeing on it, Dr. Ages finally rolled up and hauled to the curb.

One day Delayna breezed in while I was cleaning the master bath. "Hi," she called cheerfully.

"Hi," I said as I flushed her husband's poop. He had just left for a golf game. I squirted the toilet bowl with cleaner and

heard Delayna in the bedroom, rustling shopping bags. I could see her crossing back and forth in front of the doorway. Then she stepped into her closet and stuffed clothes into a gym bag.

"I'm off," she said.

"Okay. See you next time."

Her heels clipped through the house, the door opened and shut, the SUV started up and pulled out of the driveway. I always breathed a sigh of relief whenever any of the Ageses left the house.

I finished up the toilet and then moved all Dr. Ages's shaving creams and colognes and athlete's foot products off his countertop and cleaned the sink and the mirror. Then I replaced it all and went on to the shared shower. Then on to Delayna's private toilet and sink area. I mopped my way out and turned to face the room.

Delayna's new purchases were spread across the rumpled sheets of the bed and the bags were dropped to the floor. I'd have to move her latest acquisitions in order to make the bed and I'd have to move the shopping bags in order to vacuum. I picked the shopping bags up, folded them, and wedged them behind a suitcase that was stashed in a corner. Then I moved Delayna's new clothes. As I did so, I took a look at the price tags.

There was a blue velour sweat suit for $150. A leather handbag that cost $200. A pair of pajamas for $60. A silk shirt for

$75. And five new pairs of underwear, $30 each. I burst out laughing.

What made this so funny was the book I was reading, the one I couldn't wait to return to. In fact, it was in my bag, and after I finished cleaning the Ageses' house, I planned to go to my favorite café and get my favorite espresso milkshake and, hopefully, if it wasn't occupied, sit on my favorite couch and read. The book I was so anxious to get back to was *América's Dream* by Esmeralda Santiago. Its main character is a maid.

I laughed when I saw Delayna's $30 underwear because I had just read a scene in which América is straightening up her employer's dresser drawers and she notices the price tags left on bras ($30) and panties ($15). She is shocked at this and she tallies up the underwear drawer at $750. Apparently I was not the only maid that fell into the habit of counting things, because América moves on to the closet, where she counts the shirts, the pantsuits, the fancy dresses with matching beaded shoes, and the regular shoes. Some shoes are still in their boxes with the stickers on them. A week's salary for América equals a pair of shoes for her employer. América determines that she will ask for a raise. The raise is denied, which made me fume.

I was hooked on this book from the opening scene, in which América is on her hands and knees scrubbing behind a toilet. She is "in the middle of her life," the narrative says, just as I was in the middle of mine. Only one hour before choosing

América's Dream from the library shelf I too had been on my hands and knees, scrubbing behind a toilet.

I loved América from the beginning. She is a real maid doing a real maid's work. She is voluptuous and beautiful and, in spite of an abusive relationship with the father of her child, she is strong. And América has none of the stereotypical qualities of most literary maids.

Those maids are almost always fat. And they almost always have jiggling double chins or a mole with a frightening black hair springing from it. They lack social graces and they talk too much. They do more eavesdropping than actual housework and are often seen pretending to dust when some crucial information is being passed between the other characters in the drawing room. Of course whatever is overheard will predictably be repeated to another character, one with enough brains to piece it into the larger puzzle of the story. The maids I have encountered in literature are mostly buffoons, used as comic relief or to properly thicken the plot, like cornstarch thickens a stew. Before reading *América's Dream*, I knew of only two authors whose main characters were maids.

There are the Blanche books by Barbara Neely, in which Blanche really is a housecleaner-turned-detective. And there is my own *Home Across the Road*, in which a domestic servant named China Redd works in the old Roseberry Plantation, a house that holds her own history as well as the history of her

white employers. China is descended from slaves that helped build the white Redds' wealth.

China is not fat or stupid. She has no double chins and no hairy moles. She does a lot of real work and she knows an awful lot about her employers. But they imagine that she is "practically family," preferring their fantasies to who she really is.

When I was writing *Home Across the Road*, a friend of mine joked that no one would ask if this one was autobiographical. And she was right. No one did. China Redd is African-American, so presumably we have nothing in common. But, in fact, *Home Across the Road* has more autobiographical elements than *Life Without Water*. When *Life Without Water* was published, many people assumed I'd grown up on a commune and been born to hippie parents. One reviewer stated outright (without doing any research) that *Life Without Water* was not a novel but was instead a "thinly disguised memoir." That was news to me and to my family.

I have never lived in a commune and my parents are of the World War II generation, not the Vietnam generation. I have, however, lived in the kitchen house of an old plantation, and I have worked as a domestic. I know something about the invisibility of that work. I know the thanklessness and the endlessness of it. And I know the platitudes. "We just don't know what we'd do without you," backed up with a $20 Christmas bonus or, in the case of Dr. Ages, nothing. I wanted to tell Dr. Ages

and Delayna that all the money in the world won't make you classy, nor will it keep your dog from peeing inside the house if you never let him out.

In the Ageses' household, I moved the $150 blue velour sweat suit, and the $200 leather handbag, and the $60 pajamas, and the $75 silk shirt, and the five pairs of $30 panties to a chair. Then I made the bed and moved it all back again. Then I vacuumed and readied myself for some deep-sea diving in the sunken tub.

I hurried through the remainder of my work. I was never as good a maid as either China Redd or América Gonzales and I know I charged more. The Ageses could have gotten someone else for less, as one of Delayna's chums was constantly pointing out in my presence. But even without the job security of knowing that I was the cheapest maid available, I hurried through my work. After all, I had already cleaned up dog pee, and flushed poop, and purchased Drano, for which I would not be compensated. Screw 'em. I had an important date with a milkshake and a book and a voluptuous, smart maid named América.

7

THE WRITING SPIDER

I like the days that I clean the Morelands' house. When I come driving up, Ned is almost always sitting in a deck chair just inside the open door of the garage. I pull my car past the driveway and then I back in and Ned playfully holds out one foot while I pretend to gun it. Then he stands at the back of my car with his arms outstretched, waiting for me to give him something to carry. I grab the light gear, my bucket and mop, my kit and my rags, and Ned hauls out the heavy stuff, my vacuum cleaner and the gym bag full of attachments.

We always talk about nature. We discuss the arrival of the hummingbirds or he tells me about the baby wrens coming to

the feeder or the snake he got out of his neighbor's garage. Once he took me out front and pointed to the garden spider living in the boxwoods. Her web had a thick white zig-zag spun into the center of it. "Isn't she beautiful, Nance?"

"They're called writing spiders," I told him. "Presumably, if it spells your name, you're going to die." I twisted my head to the side. "That looks like an N," I said.

"Yeah. N for Nancy," Ned answered.

His wife, Jen, came out the door. Jen hates bugs, and although spiders are not technically bugs, they fall into that category for her.

"I told him to knock it down but he won't do it," Jen said. She stood at the edge of the yard. "And I'm not getting near it."

"Well, look at it this way," I told her. "She's helping out by getting rid of other bugs."

Jen considered this and said the spider could stay. But she knew Ned wouldn't knock it down anyway. He loves spiders. When I first started working for the Morelands, Ned always reminded me not to kill the spider that lived in the garage.

After we've chatted about spiders and birds and snakes, the Morelands leave. I wave good-bye to them and punch the button to close the garage door. Sometimes there is a bit of comedy, as Ned is also closing the door with his remote. The garage door goes up and down, up and down. Ned and I look at

each other and one of us points, meaning you do it. Once that's settled and the garage door is closed, I fill my mop bucket at the laundry sink and disappear into the house. I won't see the Morelands again for two weeks.

The house is two stories with two and a half baths. I never mind being there. The Morelands are predictably friendly and once they leave, I am predictably alone. I can turn on the TV and half-listen to *Unsolved Mysteries* while I clean the kitchen.

There is no clutter in the Moreland house. Jen runs a neat and organized household. The dirt that I will have to deal with is kept to a minimum by the fact that it is not trapped behind and under things. The surfaces I am supposed to clean are available to me, and easy to access. Even though it is still hard work, there is something relaxing about cleaning the Moreland house.

My housecleaning friend Lindy and I differ in our opinions of clutter. She says clutter equals less cleaning, because there is less space available to clean. Her policy is not to move clutter but to work around it. That's my policy too, but I still don't like it. I feel my psyche unraveling whenever I am surrounded by clutter. I also feel that I am just enabling people in their life of not taking care of things.

After years of cleaning houses and claiming little rental hovels as my own, I have come to believe that inanimate objects have feelings, or at least energy. I can feel the difference

in a cared-for, well-lived-in home and a house that is more like a status symbol, or a staging ground for chaos. I find it odd that in just about every mansion I've ever cleaned there has been at least one picture of a little cottage with smoke curling out of the chimney. I always took this as proof that in this culture most of us find ourselves too far away from our inner peasants. What we would really like, deep down inside, is a simple, uncomplicated life. I wonder if most people would be living in the houses they are living in today if it weren't for status and cultural expectations. But without status and cultural expectations, I'd probably have to make my living on writing alone and then where would I be?

The Moreland house is no cottage. It's a midsize suburban. It sits on a street lined with similar houses and similar green lawns. But compared to a lot of the houses I've worked in, there is an uncomplicated energy to it. The trash never piles up. Dirty clothes are never tossed all over the floor. Unopened mail never accumulates on the kitchen counter. Jen's few bottles of cologne and lotions are lined up neatly across the bathroom counter. And her extensive collection of teddy bears is set in an orderly display throughout the house.

The teddy bears are lined up on the couch and all the chairs of the formal living room. There are teddy bears sitting on coffee tables and bookshelves and along one side of the staircase. The smallest ones are sardined into baskets that sit

on either side of a bench, where three more teddy bears sit. Jen loves her bears as much as Ned loves his spiders. She has biker bears, bride bears, bears in calico dresses, bears in leopard-skin jackets, and even naked bears in nothing but fur.

My favorite bear has burgundy fur and gold eyes. He caught my attention because he always falls off his little bench while I am vacuuming. At first I just propped him back up again but then I started giving him a hug. He looked like he could use one. Those fiery yellow eyes looked more like the eyes of a stuffed dragon. I ruffled his head once and said into the empty house, "You got the wrong eyes at the factory, didn't you, Bud?"

When you clean things on a regular basis, you have a relationship with them, even if they don't belong to you. This is a lot of relationships for me, and if the household is unpredictable, I dread going there. What will I find? What will I be asked to do? Who will be there, getting in my way? At the Moreland house things don't change much.

Sometimes a mirror with a flowered frame replaces a different mirror with a different flowered frame. Or a new bear is added. Or one wreath appears while another disappears. But basically it's always the same and I love that. Ned is always in the garage. He always helps me carry things inside. We always talk about nature. Sometimes Jen gives me clothes that she's getting rid of. They are both always nice, respectful, and appreciative. When I returned to work after having been gone for

six weeks with an injured back, the Morelands slipped an extra fifty into my pay.

Some writers thrive on a constantly changing landscape, while others thrive on routine. I do better with routine, but I've discovered that opinions run strong. They run especially strong among people who don't write. They've all read books, so they know everything there is to know on the subject of real writers. Many are perfectly willing to tell me that if I want to be a real writer, I am going to have to do things a little differently.

Here is a list of the advice I've received:

1. You must spend some time living abroad.
2. You must trade in your Mac and write on a PC.
3. You simply must read Proust.
4. You simply must subscribe to *The New Yorker*.
5. You simply must subscribe to every literary journal there is.
6. Buy only hardback books.
7. Get an MFA in creative writing.
8. Go to an artists' colony.
9. You have to attend lots of conferences.
10. And you have to network, network, network, and never forget that everyone you meet is a potential source for something besides friendship.

When I asked where all this money and free time were going to come from, the advisers invariably blinked and answered, "Why, from writing, of course." This was definitely advice from the uninitiated, and if I had listened to even half of it, I'd still be just a housecleaner. My role would be clear, well-defined, and cemented in the belief that I couldn't be a writer because I didn't live a life that looked like the lives of other writers.

Every writer has to work with what he or she has, and I can tell you that there is no such thing as a perfect writing life. There can be perfect writing days, but they are usually dots in the calendar of imperfect writing days. We all have to learn to work anyway, no matter what is going on around us.

I tell anyone that wants to write, but isn't writing, that each of us gets 168 hours every week. Amazingly prolific writers never had more than 168 hours in a week. It is true that they might have had cooks and nannies and even housecleaners, but they never had any more time in a week than we do. And time is everything. Time is the comforting blanket that cloaks all our days, and the rug that we are constantly pulling out from under ourselves. The most important things to remember about time are that you need it and that you have it.

Writing is probably better for all the imperfections of our lives. Fiction requires tension, and the first tension is between the story trying to be told through the writer and the writer trying to find the time to sit down and get it onto the page. I

believe this is a good thing. If writers were not willing to work with this tension, then books would be as flat as reality TV. We don't read fiction for reality; we read it for truth.

I cringe whenever a writer asks if I'd like to hear about the book he is working on, or in some cases not working on but merely thinking about. "Write it down," I tell him.

"Oh, I will. But don't you want to hear about it now?"

No, I don't.

Don't break the magical spell of writing a story and waiting for it to evolve, day after day after day after day. Don't dither away the energy with cocktail chatter. Don't give your baby any form other than the written word.

Stories want to be born, but they aren't attached to the form that they take. A story is just as content to be told orally as it is to be written. If I go around telling it to everyone, it's happy and gone. The tension is over. Talking about a work in progress to anyone but the most carefully chosen people is a death knell.

Writing is so crazy. There must be a million things to do that are saner than writing. On the one hand, I want people to be interested in my work, but on the other hand, I don't want to talk about it. When I am writing, I am living in two worlds, and the fictional world that I visit every day, the one I can't talk about, influences the real world, and vice versa.

Every day I have to pull myself out of the dream that I know I will return to. I have to shake off a world that is as real to me

as my own kitchen. It feels a little like living a double life. It feels secretive. If one of my characters suddenly dies and I am moved to grief, or even tears, I can't share that with anyone. I can't explain it. I leave my desk sad. I go to work sad. Shit happens and sometimes I can't think of anything to say when asked, "How was your day?"

I think this is why I thrive on routine. I like for the real life, the one that involves going to work and cooking dinner and being in the physical world, to be somewhat predictable, because there are enough surprises in the alternate life. And truly there are enough surprises in the real life too. Shit happens there as much as anywhere.

And then there are the tiny things happening every day that go unnoticed. We whiz by them and give them no thought. But those tiny things are important. They influence my fictional world. They give me the concrete details that marry fiction to reality. Writers don't need to live abroad in order to practice their craft. All we need to do is open our eyes to the lives we live now. We need to notice the return of the hummingbirds, the wrens nesting in the backyard, the snake in the garage, and the spider in the boxwoods.

8

SEASON'S GREETINGS

Hank and Anna were getting a divorce. I did not know this when they hired me, but as I cleaned their house week after week, it became apparent that something was going on. The house felt tomb-like, as though something inside was dying. As it turned out, something was.

Vibes are supposed to be intangible, but these were strong and hard to ignore. Still, I couldn't pinpoint exactly what the problem was with this house, and I vacillated between telling myself it was my imagination and telling myself that something was definitely wrong.

Then Hank and Anna stopped talking to each other and

started communicating with terse notes left on the kitchen counter. I don't snoop. I don't open drawers or read diaries or letters. But these notes were left right out in the open, left like a recipe on the blue Formica.

From Anna: "John is embarrassed about the condition of his room. He doesn't want to have friends over."

From Hank: "What do you want me to do about it?"

From Anna: "Paint it."

From Hank: "What color."

From Anna: "He's your son too. Ask him."

In the family room, the sofa bed was always pulled out, made up, and covered with a hodgepodge of mismatched sheets and blankets. Hank's toiletry kit was kept on the back of the toilet in the downstairs' bath. Meanwhile the master bath, upstairs, was filled with Anna's cosmetics and perfumes. Small votive candles lined the edge of the bathtub, and there was a basket of bath salts in individual envelopes, all labeled "Stress Relief."

From Anna: "What is your estimated move date?"

From Hank: "I told you already."

From Anna: "Tell me again."

I could map the progress of Hank's exit by the way the job of dusting changed week after week. One day, when I arrived, everything had been emptied out of his desk and was heaped on top. I couldn't properly dust his desk with all that stuff on it, so I flipped my feather duster around the edges and across the

lamp, and moved on. The next week Hank's desk was clean and empty, looking as blank as one half of a tombstone, waiting for a spouse to die. So much empty surface begged to be polished, so I pulled out the Pledge. Then I moved on to dust a collection of American Indian pottery that would be gone the following week, leaving an empty shelf and another surface begging for Pledge.

From Hank: "They're putting up the new Sheetrock. These things take time. It won't be until the first of the year."

Anna came home the day that note was left. I was vacuuming the living room when out of the corner of my eye I caught her waving to me. I cut off the vacuum.

"I didn't want to scare you," she said.

"Thanks." I unplugged the vacuum and wound the cord up into a loose circle, getting ready to move to another part of the house.

Anna paused in the kitchen and read Hank's latest reply to her latest note. Then she sighed and said, "It's hard being separated under the same roof."

"I thought something was going on," I said.

"Yeah. Hank's moving out. He bought a duplex in Pittsboro and is having it remodeled before he moves in. That's why he's still here. He was supposed to be out before Thanksgiving and now it looks like he'll be here for Christmas."

"Where's he moving his stuff?" I asked.

"The duplex. One room's ready and he's storing it there."

Anna picked up the pen that was always lying beside the notes and bent down to scribble something. When she looked back up, she said, "I'm just getting a sweater. I'm going out tonight."

After I was sure that Anna was gone, I went straight into the kitchen and read her last entry.

"OK. We'll need the Christmas stuff. It's in the attic."

The next week there were boxes of Christmas decorations stacked at one end of the den. As Hank's things continued to disappear, Christmas began to appear. First the mantle was decorated with a village of ceramic houses with lights inside. There were little carolers standing around with their mouths open, kids sledding down a plastic snow–covered hill, and a small round mirror with a man and a woman ice-skating hand in hand. John's stocking hung forlornly in one corner.

From Anna: "This is really hard on John. I think we ought to buy him something especially nice. He'd like a go-cart."

From Hank: "Where's he going to ride a go-cart?"

From Anna: "You could make him a track in the back-yard."

From Hank: "I'm happy to go in together for something nice for John, but I don't have time to build a track in the back-yard. I'm moving. Remember?"

Hank's empty desk became a staging ground for present-

wrapping. Rolls of wrapping paper were leaned against one open drawer, and scissors and tape were left on top, along with scraps of paper and ribbon. Wrapped presents accumulated along the back edge. Every one of them was tagged, "To: John From: Mom."

From Anna: "We could use a tree to put all these presents under. You haven't done any shopping. What do you have for John? I'm not doing your shopping this year."

The next time I came to clean, the tree was up and there was a fire in the fireplace. Hank was sitting in an armchair staring into the flames. He turned when I opened the door; then he stood up and held it for me as I hauled in my gear. "I forgot you were coming," he said.

"Sorry. I hate to interrupt a peaceful moment."

"There are too few of those," he said. "I guess Anna told you what's going on."

I nodded.

"I'm going to really miss having a fireplace. My new home doesn't have one."

"Sit as long as you like," I told him. "I can start upstairs."

He looked at his watch. "Maybe I will."

Hank settled back into the armchair and I went upstairs. I could hear him feeding the fire as I moved the votive candles off the edge of the tub in the master bath. When I went back downstairs to get my vacuum, I said, "Pretty tree."

Hank looked at the Christmas tree. "All those ornaments," he said, sweeping his hand in the air, "are hand-blown glass from Germany. I gave them to Anna for our first anniversary."

"When did you get married?" I asked.

"Ten years ago today."

"Oh. I'm sorry."

Hank shrugged. "Que sera, sera." He looked at his watch. "I've got to be going. I'm taking the day off to Christmas-shop." He picked his jacket up off the back of the chair and shrugged it on. Then he leaned over and picked up a log, and settled it onto the fire. "It should go for another hour or so," he said. "Sit down and enjoy it."

"Tempting. But I can't sit for an hour."

"Maybe for a minute or two?" he said.

"Maybe."

Hank went to the kitchen. I heard the pen scratching across the notepaper, and then the back door opening and closing. Through the picture window I watched him back out of the driveway and then I sat down in his chair and watched the flames. In spite of everything that was going on in this house, the fire and the Christmas tree felt good. I closed my eyes, leaned back, and thought about my writing. I knew that soon Christmas would be interfering.

All year long I sit at my desk and try to draw a cloak between myself and the world. At the same time, I am trying to open a

curtain to the invisible world of story. Like the invisible vibes in Hank and Anna's house, I know the world of story is real even before I put it down on paper.

There is always the matter of trying to find the time to write, but at Christmas there is also the matter of psychic space. Christmas creeps into my brain, whether I want it there or not. The endless loop of carols playing on the radio, at the mall, over speakers at the gas station are ominous to me. At first they remind me that the big consuming event is on its way. Then they remind me of everything I have yet to do before the actual day.

Hank was probably out there right now, maneuvering his Jeep into a tight parking space and sadly taking his charge card to find a gift for his son, a gift which, if he followed Anna's lead, would be a compensation for the pending divorce. I was pretty sure that theirs would be a big Christmas. I always try to keep mine small. Even so, no matter how small I try to keep it, Christmas takes enormous amounts of energy. There are too many things to think about regarding Christmas, and the day will arrive when they have butted writing right out of my head. When this happens, I pack up my papers. I make note of where I am in my manuscript. I close the laptop and throw in the towel. Christmas is here and I've done well to hold on to my routine as long as I did.

I've learned to fight it and then not fight it at all. My work

will wait for me. It will be there when Christmas is over. This is one of the understandings I have negotiated with my writing. It knows I will be back and I know it too. The opposite of Anna and Hank. They both know that once Hank leaves he won't be back. Their routine is probably shot forever.

I rousted myself from the chair in front of the fire and started cleaning again. But the fire was so cozy that I didn't want to leave the room, so I decided to finish the upstairs later, and dust and vacuum where I was for now. Dusting this room was simple. There weren't any pictures or mementos to worry over. When I'd first taken the job, I'd noticed that there were lines in the dust along the top of an antique desk, and now I suspected that wedding pictures and family pictures had once rested there. But, except for one red-and-white striped candle sitting in a glass dish, it was empty now. I moved the candle and sprayed the top with Pledge, wiped it clean, and moved on to feather-dust the window ledge and Pledge the coffee table. Then I cut on the vacuum and started running it across the rug. Back and forth, back and forth, working my way toward the tree. Suddenly the beater bar of the vacuum caught the velvet tree skirt and started the whole tree falling toward me. The tinsel swayed. The star on top threatened to collide with the light fixture. Worst of all was the way the hand-blown German glass ornaments that Hank had given to Anna ten years ago, tinkled against each other.

Out went my left hand. Up went my right foot. One to catch the tree by its trunk. The other to cut off the vacuum and stop the consumption of the velvet tree skirt.

I got lucky that day. Nothing was broken. I righted the tree, and then unplugged the vac and disentangled the tree skirt from the beater bar. There was not even a tear. I smoothed it out and carefully arranged John's presents back the way they had been.

I needed to sit a minute and calm my nerves. I sank down into the armchair in front of the fire and stared into the flames. Jesus, that was close. I imagined Anna coming home and finding all her ornaments broken, swept into a paper bag that was now on the kitchen counter, with an apologetic note from me sitting next to the ongoing marriage memo she shared with Hank. Then I remembered that I'd been distracted by the comfort of the fire and hadn't read his latest installment. I got up and went to the kitchen.

In Hank's crooked scrawl: "Can't we work this out?"

9

MOLLY'S SMILE

I clean the house of an ex-boyfriend. How's that for karma? Back when James and I were a couple, we moved in together a little too quickly, before we knew each other well enough. And before I'd had a chance to get a handle on his domestic habits and survey the desk he had stored in a friend's barn. "It's a great desk," James said. "I got it out of a Dumpster at UNC."

This did not alarm me. I am not at all opposed to a little Dumpster-diving. A friend and I used to hit the dormitory Dumpsters every spring, when the students left town. We pulled out refrigerators, clothes, tables, microwaves, toaster ovens, lumber, lamps, chairs, a pasta maker, crystals, paintings, and even jars of

money. We culled what we wanted and had a yard sale with the rest. We almost always earned at least a hundred dollars each.

What's more, I once lived on a small street with a long-standing Dumpster run organized by my neighbors. They had been doing it for years and had it down to a science. They knew when to hit the grocery stores just when the food was being put out. We scored boxes and boxes of perfectly fine food, which we divvied up on the deck of one woman's house. What we couldn't use went to feed another neighbor's urban chickens.

So, when James mentioned his fabulous desk pulled from a Dumpster on campus, I was open to it. I had been living in a fourteen-foot travel trailer and had no furniture. I needed a desk for my writing and I assumed this would be the one. After all, James had said it was fabulous and I had no reason to doubt him. But this turned out to be the first place where James and I found that we differed. I would have left that desk in the Dumpster. The top was concave. Nothing could have stayed put without Velcro. Not a typewriter, not a jar of pencils, not a mug of coffee. An open notebook would have closed. It was like a desk out of *Pee-Wee's Playhouse*.

"That thing is not coming into my house," I said. And James complied. We moved in together, got through a tough winter together, and split up come spring. It was a quick romance but James remained a friend, and when we ran into each other over the years we would stop to catch up.

He married a woman he had been dating for a while. They had a baby, and lived in the same rental house that my Dumpster-diving friend once lived in. Then they moved to the mountains, returned, bought a house in a suburban neighborhood, and eventually broke up. I hadn't seen James for a long time when we ran into each other in the parking lot of a grocery store. As it happened, he was in need of a housecleaner.

I guessed correctly that without the constraints of a relationship, James's dirty clothes were probably piling on the floor and change was probably spilling across the top of his dresser, while socks spilled from the drawers below. There would certainly be dishes in the sink and stacked on the counters. And there would most likely be food stuck to the stovetop, cat hair adhered to the couch, and papers dropped to the floor. Based on these images I came up with an estimate.

It turned out, James's teenage daughter added her bit to the mess too. Clothes on the floor, pictures cut from magazines on the floor, open makeup bottles on the floor, and toothpaste caps rolled behind the toilet. There were lotions and potions spread all across the edges of her bathroom. Wet towels flung across the tops of doors, and book bags and pocketbooks spilling their contents into the hallway. There were earrings that I heard, too late, rising up into the wand of my vacuum cleaner.

I picked up what I could at James's house, and the rest I scooched to the edges of each room with my feet. I made a

few executive decisions regarding the contents of his daughter's bathroom. If open makeup looked dried and caked, I threw it away. If an almost-empty shampoo bottle sat on the edge of the tub for a month, I threw it away. Slimy bars of soap that had been replaced by new and improved bars of soap also got tossed.

I knew I would never be able to make James's house immaculate but I also knew that James wouldn't expect it. He just needed someone to come in every other week and knock the top layer down. And that's what I did and we got along fine.

James worked at home, so I saw him a lot. I enjoyed being around him again. All the qualities that had made him attractive in the first place were still there. He was fun to talk to and a good person and we made each other laugh.

Then he started dating Lillain. Lillain could not stand the disorganization and clutter of James's house and one day, early in their relationship, she started cleaning. She bagged and threw out old blankets, broken toys, dead ballpoint pens, dead plants, pots with scaling bottoms, and the avalanche of receipts that had always drifted from the kitchen counter to the floor. Suddenly there was a designated drawer for batteries and flashlights. Sheets were no longer wadded and crammed but now folded and stacked. Old medicine disappeared from the top of the refrigerator. Half-used boxes of detergent were consolidated

and hardened boxes were tossed. And the piles of dirty clothes that had littered the landscape like a range of mountains were washed and put away. When I walked in the door and saw it for the first time, I said, "Holy shit!"

James came bounding up the stairs from his office in the basement. "What do you think?"

"I think you ought to marry this girl before she gets away."

James smiled to himself. "I just might," he said. "This woman . . ." He shook his head and his eyes went soft.

I had met Lillain and liked her, but this didn't keep me from feeling a little apprehensive. Was my life going to be easier because I could reach more surfaces now or was it going to be harder? For the first time ever I was able to clean the top of James's dresser, the top of the refrigerator, and a portion of the kitchen counter that hadn't seen the underside of a sponge in years. There were lots of places available to clean now that had never been available before. I knew it was going to take me a little longer to clean James's house this time, and it did, but the time was nothing compared to the psychological relief of Lillain's clutter-clearing. When I left James's house that day, I felt satisfied. Rather than feeling that I had enabled disorganization by making it tolerable for another two weeks, I felt that I had contributed to what was becoming a well-run home.

I admired Lillain's moxie. James must have too, because

they did get married. They had a baby and sold the house in the suburbs and bought an older house in town and I moved with them.

Everyone likes the new house better, including me. Besides Lillain's sensible presence, it has very little carpet, is mostly hardwood floors, and the style is more comfortable and venerable. Lillain and James and the baby and sometimes James's daughter are all home when I clean, but they never get in my way. I like seeing them and almost every time I am there I stop cleaning and Lillain stops what she is doing and we have a nice chat.

She bought a microwaveable heating pad for me when my back was hurting, and I copied my spine alignment exercises for her when her back was hurting. Once we sat down together and listened to Mayor Ray Nagin's searing interview during the Hurricane Katrina disaster. Lillain is great. I couldn't be happier that James married her. And Molly the baby is beautiful. I love the smile Molly gives me when she first realizes I am there. It's wonderful to have a baby's whole face light up when she recognizes you. And, frankly, I would clean all the toilets in the world for a smile from Molly.

The workload in a house with a new baby always increases. There are toys to pick up, blankets to fold, crusted food to scrape from the floor around the high chair, and naps to tiptoe around. But the baby energy that makes these houses the hardest to clean also makes them the hardest to leave.

There are certain things I do with babies. I flutter my lips. That usually gets their attention. And I hold one hand up and pull my yellow rubber glove off, and that interests them too. Of course I love to hold them, but I am careful to always wash my hands first.

Lillain is good about letting me touch and hold Molly. She is not one of those hovering mothers who think the healthiest environment for their babies is a bubble without germs. I always quit those houses, because cleaning a house with kids usually means I take home more germs than I bring in, and what I do is hard enough without being made to feel like I am something filthy and dangerous.

I also quit because I feel guilty working around babies that are imprisoned inside suburban cribs and never taken outside for walks. I've seen babies smiling at me from their little cages and I smile back and coo a little, but even if they reach for me, I don't wash my hands and get any closer. I've been told flat-out to keep my distance. Don't touch the baby.

Lillain is not like that. She and James welcome my interactions with Molly and I look forward to cleaning their house every two weeks and seeing how much the baby has grown.

When Lillain and James first got together, he gave her his copy of my first novel. She read it and loved it. I remember the day he asked me to sign it for him. I wrote, "To James, Keep it clean."

We have always talked about books. James turned me on to Cormac McCarthy, giving me a copy of *Child of God* early in our relationship. I read it and couldn't speak for three days afterward. Now, when I go to clean their house, James and Lillain ask me if I've read anything good lately and I ask them the same. If they are too busy for this conversation, I peruse the books that are stacked beside their bed. When James was reading *The Da Vinci Code,* he let me know everything that he disliked about it. And when I was listening to *Snow Falling on Cedars* on my Walkman, we talked about what an amazingly skillfully written book it was, as well as a great story. Talking about literature and sometimes writing has always been a part of knowing James and Lillain and cleaning their house, so I wasn't surprised when James came bounding up the stairs one day with a *Newsweek* in his hand while I was down on my knees cleaning the toilet.

"Nancy, my cousin wrote a novel."

"That's great." I plunged the brush up and down and rubbed it around the rim.

"She's here in *Newsweek,*" he said.

"Is it her first novel?"

"Yeah."

"Making it into *Newsweek* with her first novel is pretty damn good," I said—cheerfully, I hoped—as I had been working on my nagging jealousy of successful authors.

Rosemary Daniell, author of *The Woman Who Spilled Words All Over Herself*, says that "envy is the gift that helps us know what we want for ourselves." I like envy framed that way, but mine was a harsher shade of green. Mine was the kind that would shut me down as a writer, the kind that would make me give up on myself, and think that I just didn't have what it takes. At the time James bounded up the stairs with the *Newsweek* in his hand, I was trying out self-imposed cognitive therapy. I tried to feel nothing but joyful happiness for the financial success of other writers, and now I was being asked to feel it while cleaning a toilet.

I had been doing pretty well with it. The less I compared myself and my situation to other writers and their situations, the more comfortable I was with my life. I felt fine kneeling on James's bathroom floor, hearing about a woman whose first novel was written up in *Newsweek*. In fact, I was surprised at this and I made a mental note to give myself a pat on the back as soon as I'd mopped the floor.

I pulled the toilet brush out and propped it into its little cup. James was rifling through the *Newsweek* article about his cousin. I closed the lid of the toilet and sprayed the tank, wiping it off with my rag. Then I sprayed the lid, the inside of the lid, the seat, the inside of the seat, and the rim.

"She got a two-million-dollar advance," James said.

"What?" The spray bottle slipped from my hands and I slumped as if I'd been hit with a two-ton wet sponge. "Jesus, James, you could have picked a better time to tell me this."

He laughed while I recovered and resumed cleaning the toilet. "Two million?" I asked, just for clarification.

"Two million," he said. "She's coming to Raleigh. I think I'll go see her."

I resisted the urge to say, Maybe she'll buy you dinner.

"I'll leave this on the coffee table for you to look at," James said, and he tromped back down the stairs.

There was nothing to do but keep on cleaning the toilet and then mop the floor. This was my last mopping job for the day, so after squeezing the water out of my mop, I opened the toilet and poured the bucket of dirty water in. I hit the handle and flushed it, all that hard inner work I had been doing around my jealousy swirling right down with it. I forgot that I was supposed to pat myself on the back.

Downstairs I washed my hands and picked up the *Newsweek* and started reading. Lillain came in, carrying Molly. "Are you reading about James's cousin?" she asked.

"Yeah," I said, shaking my head.

"I know," Lillain said. "All my cousins ever did was get pregnant at age thirteen."

I laughed. Lillain has a way of leveling the playing field.

And so does Molly. She gurgled and I looked up. She was smiling and reaching for me. I closed the *Newsweek* and held out my arms and Lillain passed her to me. She curled her fists into my hair. I fluttered my lips at her. Molly laughed her little baby laugh. "You like Nancy, don't you?" Lillain said.

10

ECSTATICALLY CLEANING
THE TOILET

The Hamiltons were old hippies who still lived in the woods and fixed a lot of pasta for dinner. They had two young boys, worked long hours, and getting dinner on the table seemed to be the day's crowning achievement. Cleaning up after dinner clearly was not. There were always strands of cooked spaghetti stuck to the kitchen counter and long sticks of uncooked spaghetti that had fallen to the floor. My vacuum cleaner could not suck up unbroken sticks of hard spaghetti. It would clog or spit it out or else the spaghetti would hover at the

vacuum cleaner's mouth as if it were gagging. Before vacuuming the kitchen, I had to sweep, and I hated that.

I also hated the fact that the two boys, El and Lee, had not been coached in the art of using a wastebasket. They were allowed to drop their trash everywhere they went. Wads of Kleenex littered the bathroom counter. Used Stridex pads covered the carpet of Lee's room. And candy wrappers were everywhere. In the days following Halloween, I could map the movement of El and Lee by following the wadded-up candy wrappers. They were along the stairs, in the hallway, in their rooms beside the beds, and next to the chairs facing the TV. Candy wrappers were something else that my vacuum cleaner would gag on.

Before I did anything else at the Hamiltons' house, I made an all-inclusive exploration with a plastic grocery bag in my hand. Stray candy wrappers, Stridex pads, and Kleenex were picked up and put in the bag. It was a lot of bending over and I'd always worked up a nice backache by the time I was finished. I'd also worked up an attitude, because by the time I'd picked up all the trash my real job hadn't even begun.

I was tempted to give it a go with the vacuum cleaner and the candy wrappers. I knew vacuums could handle a lot of things. I'd heard coins go up in mine and I had a housecleaning friend who made it a policy never to pick something up. He told me about sucking up his client's underwear with his client's vacuum cleaner. "Bikinis," he said when my eyes wid-

ened. But bikinis or boxers, this was my vacuum cleaner and I decided not to risk it. Getting a clog out during a workday was hell.

First I would have to take the wand apart, and if the clog wasn't in the two hollow metal pieces where it could easily be blown or pushed out, then it was in the hose. Getting a clog out of the hose involved turning the vacuum on and squeezing up and down the hose, trying to loosen the clog. And if that failed, it involved taking the vacuum outside, turning the blower on, and spraying dust all over the rose bushes. I worked hard at finding all of the dropped candy wrappers at the Hamiltons' house but I didn't always succeed. They had a habit of getting kicked under furniture, or hiding behind bed skirts and chairs.

Other than the pasta issue and the inability of two family members (possibly more) to use a trash can, I liked the Hamilton job. I liked the location, I liked the woods surrounding the deck, I liked the boys' rooms, which were full of interesting things like rocks and sticks and birds' nests. But best of all was my recent discovery of books on tape. The Hamiltons were never home, so I could listen to a tape without any interruption.

I'd always thought the ideal job would be one that allowed me to read books. I felt a pang of envy whenever I passed a parking deck with its attendant sitting in the little glass booth. Mostly the parking lot attendants, when they weren't taking

money from exiting cars, seemed to be reading. The lucky stiffs, I thought.

When I worked in the hardware store, I once called in sick three days in a row so that I could finish reading James Michener's *Centennial*. The thing about calling in sick three days instead of just one, I realized, was that it was very convincing. After the second day, my coworkers assumed I really was sick, and pretty damned sick at that. When I returned to work, they asked me if I felt better and I answered truthfully that I did. I'd had three wonderful days sitting by the woodstove, drinking hot tea, snacking on popcorn, and reading. I felt tremendously better.

Now that I had books on tape and my Walkman, I suddenly had the perfect job. Every week I went to the library and checked out two books on tape. It was a small library, and soon I had gone through all the novels and all the memoirs and was starting in on the self-help. I didn't enjoy the self-help books much, and listening to them meant only one thing: my supply was running low.

Every week the search for suitable books became more and more difficult. I was down to some flaky New Age books when I discovered that my local video store rented books on tape for a dollar a day. This would cost me five dollars a week, roughly twenty dollars a month. I added it into my budget. It was worth it.

But there were other problems besides my supply of tapes. It was difficult to turn a tape over or punch the buttons with rubber gloves on. And the earphones fell out of my ears constantly. And if they didn't fall out of my ears, my clients, seeing me with headphones, became extra talkative. But worst of all was that my Walkman went flying off the waistband of my blue jeans far too often.

It happened mostly during vacuuming, when the headphone cord caught on the edge of a chair or a table. It also happened when I leaned over, which I did frequently, especially at the Hamiltons' house where I picked up lots of candy wrappers.

It was at the Hamiltons' that my Walkman took its final dive down a flight of stairs. I was halfway through Annie Dillard's novel *The Living*, leaning over to pick up a candy wrapper, when the cord caught on the stair rail and yanked the headphones out of my ears and the Walkman off of my jeans. I watched it fall. Hardwood stairs all the way down. Pieces were springing loose along the way. It made a terrible clunking noise against the stair treads. I knew my Walkman was a goner but what most concerned me was the vase of tulips in the hallway. I prayed that my Walkman wouldn't launch itself off that final landing and into those tulips, and thankfully, it didn't. Instead it bounced once on the hallway rug and settled peacefully against the base of the table that held the tulips. I picked up the pieces

on my way down and added them to my plastic grocery sack full of candy wrappers.

On the way home, I stopped at RadioShack and priced another Walkman. Mine had been cheap and I wanted a good one this time. I wanted one with headphones that would stay on. I wanted one with large chunky buttons that would be easy to push. I wanted one that might be a little weather-resistant so I could safely wear it while cleaning a shower. And I wanted one that would automatically reverse the tape direction, saving me the trouble of flipping the tape. Forty-five dollars. The price had gone up and I couldn't afford it right then. I told myself to forget about it. It had been a fun fling but my tape supply had become problematic again. I was almost through all the books on tape at the video store and I hadn't scouted out a new dealer. I went back to turning on the TV while I cleaned. I went back to *I Love Lucy* and *Unsolved Mysteries*.

A few years later the local library moved to a larger building and expanded its selection of everything, including books on tape. On my first visit I noticed whole shelves full of white boxes. In the old library the tapes had been housed in plastic bags and hung on a rod. Now the books on tape had white boxes and dignity and, more important, five shelves of their own. Suddenly there were hundreds of authors available to me: Bailey White, Alice Sebold, Jane Goodall, Charles Dickens, Mark Twain, Natalie Goldberg, and Anne Lamott. Just to name

a few. I checked out two, then went to RadioShack and bought a new Walkman.

I told the salesman that I cleaned houses for a living and I needed a sturdy Walkman. One that could take a beating but hopefully wouldn't have to because it would stay in place. I remembered to tell him all the other features that I wanted. He showed me a white one, with a cover that flips over the tape to keep it dry in a light shower. The buttons seemed good. The earphones hooked around the ear, the hooks holding them in place. It was still forty-five dollars. I bought it.

Recently I listened to a series of tapes called *The Language of Life*, featuring readings by different poets and interviews with Bill Moyers. This was a wonderful experience. As I listened and worked, I became happier and happier. The red rug, which I took outside to shake, seemed as bright as a flower and the dust motes shimmered in the sunlight. The white tiles in the kitchen were blinding, like fresh snow in bright sun. Even the dryer sheet did not feel so offensive to me when I put it in with the towels. I'd made it to Coleman Barks's translations of Rumi by the time I hit the bathrooms.

Of course I'd heard of Rumi, but I had never paid much attention. Now I was on my knees, scrubbing a toilet while Coleman Barks read Rumi to me, and I was ecstatic.

Birds make great sky circles
of their freedom.
How do they learn that?
They fall, and falling,
they're given wings.

While I was listening to Coleman Barks read his translations of Rumi, my movements became more fluid. Housecleaning was a dance. I scrubbed. I sprayed. I sponged. I wiped the mirrors clean of streaks and there was not one cell in my body that resented the work I was doing. I was making "great sky circles of my freedom."

On my way home that day I made my usual stop at the thrift shop. I perused the books as I always do, and in one of those amazing intelligent-universe moments that I believe both Rumi and Coleman Barks would appreciate, I found a hardback copy of the very book I had been listening to on tape. It looked as though the book hadn't even been opened, but if it had been dog-eared and falling apart, I still would have purchased it. Clearly it was waiting for me.

In this book Coleman Barks tells me that the word "dervish" means "doorway"—"an open space through which something can happen." Now, when I clean a house, I check the dervishes for spiderwebs. How lucky, I think, to live in the corner of a der-

vish. But of course we all do. It's just that spiders know a good thing when they see one.

The Language of Life tapes kept me happily cleaning houses for two weeks, because once I was finished with the series, I started it all over again. One of my favorite poets is Naomi Shihab Nye. She said into my ear, as I scrubbed a stovetop,

". . . poems hide. In the bottoms of our shoes,
they are sleeping . . ."

Suddenly I remembered the Hamiltons' house. They were long-gone clients. I'd dropped them. The abundance of spaghetti and candy wrappers had finally gotten to me. But once, while cleaning their house, I had missed a little mountain of candy wrappers during my initial garbage sweep. The pile was between a wall and a chair and next to a pair of shoes. I was vacuuming by the time I found them and I was pissed off to see them there. Instead of turning the vacuum off and making a trip to the trash can, I scooped up the candy wrappers and stuffed them into the shoes. Take that, I thought. But now, years later, cleaning a stovetop, I wished I had been more respectful of the shoes. I did not know that poems might be hiding there, sleeping.

11

NEWS FLASH

We interrupt our regular programming to bring you this special bulletin. Housecleaner Nancy Peacock turned her talents today toward her own abode. That's right. Professional housecleaner Nancy Peacock called in sick today, but instead of bed rest or even couch rest Peacock got no rest. She spent the day doing what she spends every working day doing. She dusted. She wiped. She scrubbed. She sponged. She vacuumed and she mopped, all in the comfort of her own home. The results?

"Beautiful," Peacock says.

When asked what exactly prompted her to spend a day off

working, Peacock replied that the answer was as simple as a quick look under the bed: "Dust bunnies."

That's right, plain old American dust caused this woman to impulsively change her schedule in order to clean her own home.

"They were everywhere," Peacock says. "Not just under the bed. I was tired of coming home after a day of cleaning and seeing dust bunnies gathered under the table at the end of the sofa as soon as I walked in."

Peacock says that she picked the dust bunnies up by hand and threw them away, but by the end of the evening there would be more.

"There's a reason they're called bunnies," Peacock says, adding that she just didn't have the energy to properly clean her own house after having cleaned one or two that day already.

Peacock, who is also a writer, says that a clean house is like a clean psyche for her. She says that she relaxes more in a clean house and that her "soul" does not like chaos. "But," she adds, "my soul does not like sterility either."

A comfortable home, a clean home, these are what Peacock says create a more peaceful environment for creative work. But sometimes it's the act of cleaning itself that spurs her into writing. She says that as she was vacuuming the dust bunnies in her house, she recalled an incident that had happened years ago. "A subject for an essay," Peacock confides.

"I cut the vacuum cleaner off and made notes the minute I thought of it."

And if you're worried about the clients whose house Peacock was supposed to be cleaning instead of her own, don't. Unless she is really, really sick, Peacock says, she always reschedules, sacrificing her Saturdays if necessary.

The incident that I remembered while cleaning my own house took place just after *Life Without Water* was published. I was new to this public-life thing. I was green and I felt startled whenever I was introduced as the novelist Nancy Peacock. I was also lonelier in this unfamiliar role than I had ever been in my life. I felt vulnerable, so vulnerable that I could not say it, and even if I could have said it, I doubt that many people would have been willing to hear it.

Most of my acquaintances wanted to hear about my exciting adventures as a published author. They did not want to hear how intimidated I was. How I felt unsophisticated, and out of place, kind of like Big Bird wandering away from *Sesame Street*. Suddenly the most comfortable places I found myself were in the houses I cleaned, and behind the deli counter at the high-end grocery store where I moonlighted, a job I had taken before my book was published, believing at the time that my life of writing and working as a housecleaner was just too isolated.

It's not that the people I met on book tour were not nice. Most of them were enormously nice, but it made me squirm to find myself sitting at a dinner table while intellectual conversation swirled around me. Subject matters included the names of the muses (I hadn't known there were more than one), tenure and vitae (I'd heard of tenure but not a vita), sabbaticals (I thought this happened to priests), and authors whose works I'd never read or, worse, had tried to read and couldn't. Usually I sat quietly, offering as little commentary as possible, smiling and nodding and trying to figure out which fork to use.

The day before, I would have been in my element, down on my hands and knees on a tile floor, scrubbing some other woman's toilet. The shame I felt about this flushed over me (no pun intended) like a hot flash. I would look down at my hand holding the brightly polished salad fork—at least I hoped it was a salad fork—and notice that my skin was dry and wrinkled and my cuticles hard and torn. My hands were housecleaner's hands. They were not writer's hands. My brain was not a writer's brain. It was all I could do to hold up the façade.

I was always tired on book tour. It was not just the triple life of working in the grocery store, cleaning houses, and being a new literary promise that wore me out. It was also the socializing. I've heard that the definition of an introvert is a person who draws more energy from time alone than from time with people. That would describe me. It's a stretch for me to go

to one cocktail party, much less cocktails before dinner, then dinner, then more cocktails at the bar. The next morning there is a reading, an interview, a book signing, all followed by yet another cocktail party, yet another dinner, yet more drinks at the bar. I could clean a house a day and then pull a six-hour shift at the grocery store, but it was becoming apparent that I didn't have the kind of stamina it took to be a successful writer.

At one particular event, the event that I remembered while cleaning my own house, I had already been to the first cocktail party and the first dinner, but I had artfully slipped away from the dessert party and drinks at the bar. The next day, ten authors were reading at a literary festival. I was scheduled as the second reader. That's a good spot for me. It means that I don't have to go first but it also means that my reading is behind me quickly, so that my nervousness doesn't interfere with focusing on the presentations by the other writers. I planned to read from *Life Without Water* and then answer questions from the audience. I'd practiced my reading at home, endlessly, in front of my new full-length mirror. I didn't even own a full-length mirror before the book tour, but now that I was a published author, I figured I needed to know how I looked in totality. I felt prepared for the reading, but the questions and answers would be more of a crapshoot. Still, it had always worked out before. I knew by now that if I warmed up with the reading, I'd probably be all right

by the time we got to Q&A. But I began to have serious doubts during the first writer's presentation. He was reading a speech. No Q&A. Oh my God, I thought. I need a speech.

I rushed to the ladies' room, where I closed myself up in a stall and sat on the toilet. I pulled my notebook and pen out of my bag and started to write a speech. I'd never written a speech in my life, and after a few minutes I thought, This is really stupid. I packed my notebook and pen away and left the stall, left the ladies' room, returned to the auditorium where I stood in the back, listening.

It wasn't ten minutes before I lost my nerve again and returned to the bathroom to try and write that speech. But again, no speech came. Back to the auditorium. Then back to the bathroom. Then back to the auditorium. And back to the bathroom again. Still trying to write that speech.

The fourth time I was sitting in my usual stall when I heard the door open and the sound of a heavy mop bucket being rolled across the tile floor. Lumpity-lumpity-lumpity. I leaned down and looked beneath the door. I could see her feet, fat white shoes and thick beige support hose pulled over swollen ankles. I closed my notebook and put it in my bag, flushed the toilet for good measure, and stepped out into the room.

She was an older white woman with silvery gray hair cut into a bob. She wore a gray uniform dress, with a white collar, white cuffs on the sleeves, and a white apron sewn into the

seams. A plastic name-tag was pinned above her left breast. It said, "Delores."

"Lordy," she said. "I didn't know anybody was in here. I can come back later."

"That's okay," I told her. "I just need to wash my hands." I stepped over to the sink and turned the tap on. Delores lifted the mop out of the water and plopped it between the bucket's rollers. She leaned over to press down the lever that squeezed the water out.

"You one of those writers?" she asked.

"Yes, ma'am."

"That's good," she said. "What'd you write?"

"I wrote a novel."

"That's good," she said with a nod.

I turned the tap off and dried my hands. I didn't tell Delores that I was also a maid. She wasn't the one who needed to know. I dropped the paper towel in the trash can. "Have a good day," I said.

"You too, honey." She began washing the floor, moving the heavy mop from one side of the bathroom to the other. Delores's heavy body swayed with the motion.

Thirty minutes later I was introduced, and I stood at the podium and told the audience that I had never been to college and that I earned my living by cleaning houses and working part-time in a grocery store. My voice quavered. Unless I was

asked, I had never given this information. I opened my book and began reading, letting the voice of my character take over. This was the largest audience I'd ever read to, and my first experience with a microphone. My voice boomed back to me and I remember swaying, just as Delores had swayed with her mop.

After the reading a woman came up to me and took my hands in hers. She was older, with silvery hair like Delores's. Her hands were soft and powdery. She looked me straight in the eye with her bright blue gaze and said, "Never be ashamed of what you do."

"I'm not," I lied.

She read me. "Working hard and paying your bills is never shameful," she said.

That night the writers gathered in the hotel bar, waiting to be taken to our last dinner. One of them sat down beside me on the couch. "Good reading," he said. "But why did you tell them you've never been to college? And why did you tell them you worked in a grocery store and cleaned houses for a living?"

"Because it's true," I said.

"But why tell that?"

"Because it's true," I said again.

"You shouldn't tell people that," he said.

"But it's the truth."

He pursed his lips and spoke slowly, as if to a child. "What I am trying to tell you is that no one is interested."

I felt like I had been slapped. "I disagree," I said.

I went home the next day, and pulled a shift that night at the grocery store. My coworkers wanted to know how the reading went and I told them all about it, including the ride from the airport in a limo. As we were closing for the night, I hauled the heavy black rubber mats off the floor and put them in a cart. "Jesus, I'm tired," I said.

"Oh shut up, Nancy," one of my coworkers said. "You don't have anything to complain about."

"I don't?"

"Miss Limo Girl," she teased.

"It's just a big car," I told her. "And it's not like I own it."

I slept twelve hours that night. I had a house to clean and I was three hours late getting there. But no one would know. It didn't matter as long as I got it done before the end of the day.

I unlocked the kitchen door and let myself in. I hauled my gear in. I sprayed the counter and wiped it down. I scrubbed the sink. I wiped the fingerprints off the cabinet doors. I vacuumed the floor and mopped and moved on to the living room.

I couldn't believe the two things that had been said to me in the last twenty-four hours. One: I had no right to complain about being tired, because I'd ridden in a limo. And two: No one in the literary world is interested in who I really am and what I really do. I remembered how he had slowed his voice.

I sat up in bed that night and spewed into my journal. I

wrote for pages, bitching and complaining and bitching some more. The weight of the ink made the pages crinkle as I turned them. And then I remembered Delores. "There was a woman in the ladies' room," I wrote, "when I was trying to write that stupid speech. The maid with a big yellow mop bucket on wheels and a heavy string mop and beige support hose. Delores was her name. 'Are you one of those writers?' she asked. When I told her I was, she said, 'That's good.' So it's good. I'm going to let it be good. For Delores. And me."

12

ANSWERED PRAYER

I used to live along a dead-end dirt road that snakes its way through a swamp, around a curve, and up a hill. On one side of the road sit eleven roughly built cabins and shacks plus one house that looks normal and out of place. The normal-looking house sits in the exact location of a house that burned down. The house that burned down used to be mine.

It was built of rough wood and had floors that were uneven, a roof covered in recycled tin, and siding that was once covered in tar paper. I loved that house. It was cheap living, bordered by deep woods filled with owls, raccoons, and deer. More than

that, it was the place that gave me strength enough to leave my first husband, which also meant leaving the house.

I was gone before it burned. My things were gone too, safely arranged in an old farmhouse close to the Haw River. But my spirit still dwelled there, as did the husband I'd left, and our redbone coonhound named Scarlet.

It was winter, and ever since I'd left Cal I had been counting the months till spring. I was sure that without me there to stoke the woodstove, he would find an easier place to live, a regular house with a thermostat on the wall. I was certain I would be moving back home.

I made mental lists of what I would plant in my garden and how I would arrange my kitchen this time. I knew that my porch swing would hang on the end closest to the driveway, overlooking the yard and the woods beyond. The hooks were waiting there. I'd plant morning glories and train them up a string trellis. The ground I'd dug and enriched waited too. I imagined the morning glories climbing to the tin roof and tumbling back down, blooming Heavenly Blue. I'd fix it up, make it sweet, clear out Cal's energy. I believed that my house wanted me back within its walls as much as I wanted to be there.

I thought that next summer, at the latest, I would be sitting in the porch swing, the chains creaking as I kicked it into lazy motion. I anticipated nights so foggy that the lights in my neighbor's cabin would be fuzzed, like fimbriated dahlias. And

I looked forward to winter, when I would pull my rocking chair up close to the Ashley woodstove.

Cal and I had split the cost of the Ashley, and I hadn't received any compensation when I left it behind, but that was okay. I was going to live in the house again, and leaving the stove behind meant that I wouldn't have to reinstall it. When winter came, I would sit beside it in the mornings with my first cup of coffee, stretching my feet out toward its hearth. I knew all this was going to come to pass. It was just a matter of time.

Instead, the house caught fire while Cal was off playing a gig with his band. He came home to find charred rubble still steaming from the firemen's hoses and Scarlet dead from smoke inhalation. I didn't know any of this until three days later, when the rhythm guitar player's wife called to tell me.

I went there immediately. I climbed the steps to the porch. I walked through the door that wasn't there anymore. My boots crunched on broken glass and charcoal. I went through the living room to the kitchen with sky for a ceiling now. I kicked at the rubble. I turned over this and that. There was a melted bong. An exploded mug. The cedar stump we'd built our kitchen table on.

I wandered down the hall, peeked into the bathroom with its insulation dripping from the walls. I stood at the door of the bedroom and gazed in.

For reasons I cannot explain, I returned the following week.

And the week after that, and after that, and after that, and on, and on, and on. I visited the rubble of my old home for two years. No one ever knew I did this. No one ever knew that I couldn't stay away and that I couldn't move forward. The house and its belongings didn't move forward either. Everything stayed exactly the same.

The bedroom was the least damaged part of the house. It was like a museum display. There were Cal's flannel shirts hanging in the closet. There were his pennies and guitar picks melted together on top of the dresser. His socks and underwear spilled out of the drawers. There was what used to be our bed, with its sheets fossilized from water, winter, and time. On the blackened carpet between the bed and the wall was the green circle where Scarlet had curled up and died.

Once I riffled through the pockets of Cal's shirts, looking for change. Another time I wrestled the old woodstove into the back of my truck and took it home with me. A pine plaque displaying the invitation to our wedding had survived. It sat blond and bright in the middle of my charred home. I picked it up and threw it back down. I hefted the cedar stump that had supported our kitchen table into the bed of my truck. I told myself I would build another table, just like the one that had burned. I told myself that the woodstove could be cleaned and sold. But the stump and the stove sat in one corner of the spare bedroom of my apartment, looking like aliens from another planet.

Whatever I scavenged from the burned-up house was never enough of what I was looking for. What I was looking for was gone, the house and the self I'd been when I lived there. Sometimes I looked for that self two or three times a week. I was a bartender then and had lots of daylight hours to fill and lots of time to search for something I could never find. The option to search was finally taken away from me.

I drove up one day to find a blue-and-white church bus, with a stovepipe poking from one window, parked where our woodpile once sat. It was summer, and a young woman with fuzzy blond hair sat on the cinder block steps at the back of the bus, eating a peach. I didn't stop to say hello. I threw the truck into reverse, turned around, and left in a cloud of dust.

I knew who she was. Her name was Jeri and I'd met her at a potluck the year before I'd left Cal. She would have been friendly had I stopped, but I was too shocked to find her there. I couldn't muster up manners or social grace. She'd taken my house away. It was gone three times now. Once to my ex, again to the fire, and now to the woman with the fuzzy hair, living in the bus.

I stayed away until several years later, when I heard that Jeri and her girlfriend Kathy had bought the land and were building on it. My curiosity got the better of me one spring day, and I finally drove down that dead-end dirt road once again. My house was gone, and a new two-story house with a wraparound

porch sat in its place. Just as quickly as I saw it, it was behind me. I was past it and the little cabins and shacks were going by. I felt empty, as if there was a huge bowl turned upside-down inside me.

Years later I moved back. I rented the cabin that had shared a driveway with my old house. Now it shared a driveway with the new house. Every afternoon, after a day of scrubbing and vacuuming and mopping, I dusted my truck down the dirt road toward home. In the driveway it was all I could do to turn the truck left, toward my cabin, rather than right, toward my past.

My past was my neighbor now, as were Jeri and Kathy. They knew I had lived in the house that had burned. They told me that when they tore down what was left of my old house they found the pine plaque that held my wedding invitation. They told me that Cal's clothes still hung in the closet, that the dresser drawers still yawned open, and that the mattress I'd once shared with Cal was occupied by mice.

Jeri and Kathy were good neighbors. I borrowed things from them. Mostly I borrowed their ladder so I could patch my stovepipe. Sometimes I borrowed a shovel to bury a dead mouse or a bird my cat had killed. Jeri and Kathy did not borrow things from me. I didn't have much to lend, but I provided pet care whenever they went on vacation. I liked pet-care days because I could be alone in their house, and even though it wasn't anything like my house, it was the space my house once occupied.

I would feed the dogs and the cats and then I would look out the windows at their yard. If I kept my gaze toward the yard, it was easy to imagine the rough-cut wooden walls of my old home surrounding me again. I pretended it had never burned and I pretended that I had never left.

One day Jeri and Kathy walked across the driveway and knocked on my cabin door. "We'd like to hire you to clean our house," Jeri said.

"How often?" I asked.

"Every other week."

"How about Tuesdays? I could start next week."

"How much would you charge?"

I pulled a figure out of my head and they accepted it. "Well," Jeri said. "You know where the key is. We'll be at work, so just let yourself in. We'll leave a check on the table."

"Sounds good."

They went home and I closed the door of my cabin and leaned against it. I couldn't believe it. I was going to spend four hours every other week as physically close to my old home as I could get. It felt like someone I loved had returned from the dead. I knew it wouldn't be the same, but being there would be better than not being there.

While I scrubbed the brand-new stainless-steel sink located where my old enamel sink had been, I looked out the window onto the garden I had started. I scrubbed the bathtub and re-

membered baths in my old tub, with the windows and the front door thrown wide open. I sat on one of the BarcaLoungers during lunch and remembered stoking the woodstove and sitting in my rocking chair, drinking a cup of tea and reading for hours. I swept Jeri's woodworking shop and remembered Cal's band practicing in the large back room. I remembered guitars and amplifiers and a drum set. Posters on the wall. Cal cradling his guitar whenever we sat around the woodstove at night, or on the porch during the summer.

In those days my own creative life was suppressed. I had been the one to suppress it. I had boxed it into a tiny space called "If only." If only I had more time. If only I had more courage. If only I knew what to write. And the biggest of all, if only I wasn't married to Cal.

It wasn't safe to write while married to Cal. He ridiculed the effort, and a few years into our marriage, he read my journal. After that I abandoned writing altogether. But in that house, before it burned, I had begun to gain a voice again.

One rainy day, when I was home alone, I pulled my rocker up close to the woodstove and opened the notebook in my lap and started writing. I was shy of journaling now, of telling so much personal truth, so I decided on fiction. I told myself to write a short story. I told myself to begin at the beginning and write until the end. An hour later I looked up from my notebook.

The rain was pounding on the tin roof. Scarlet lay at my feet on the green braided rug. She looked up and groaned, then settled her chin onto her paws. I gazed at the Masonite ceiling of our little shack and I said a prayer out loud. "Please God. Let me be a writer and I don't care who falls by the wayside."

I knew what I was saying. I was ready to leave Cal. Just show me the way. Let him fall by the wayside. I would never be a writer while in this marriage.

I thought about that prayer while I mopped Jeri's hardwood floors. Since I'd muttered the prayer, since I'd left Cal, not much had happened with my writing. My excuses hadn't changed much, either. They still fell into the "if only" category. If only one thing was different, then everything else would be different too. Then I could get on with it. Then I could write. It was bullshit and I knew it. I needed to stop procrastinating. The things I wanted to write would never write themselves.

During lunch I sat in one of the BarcaLoungers, and looked up to the ceiling that had replaced the ceiling I'd once prayed to. I had been granted the end of that marriage. I'd wanted that obstacle removed and it was gone. It had been gone for years now. It was me that was not keeping my end of the bargain.

I folded up the waxed paper my sandwich had been wrapped in. I got up from the BarcaLounger, put my soft cooler beside the front door, and started cleaning again. While I was vacuuming the upstairs and looking out the window onto Jeri's bus, I

told myself it was time to stop making excuses. Now that I was self-employed, I could create the time. I always got home well before the need for any dinner preparations. I could sit down and write in the afternoons. It was just a matter of doing it. I made a vow while standing in the house that covered my past. Write for an hour, I told myself. Do it today.

After I finished Jeri and Kathy's house, I lugged my gear across the driveway to my truck. Then I went inside the cabin, sat down at my desk, and began, only I didn't know where to begin. I wrote a sentence, and scratched it out, and wrote another one, and scratched it out. Finally I forced myself to write a whole paragraph. It sucked. I couldn't stand to look at it. I tried again the next afternoon and got a different paragraph, which also sucked. The third afternoon was no better. I hated going home now. I hated sitting at the desk, knowing for certain that I was not brilliant, that, in fact, I was not even capable.

The second week into this torture, I stood at the base of my stairs. I thought I was ready to climb them and sit at my desk, but I couldn't do it. I got a glass of iced tea and a bag of cookies instead, and I sat in my porch swing, gazing across the driveway toward Jeri and Kathy's house.

Something had to change. Writing after housecleaning, even after a job in which I was completely alone, was not working. I was too tired. I was brain-dead in the afternoons, even though I didn't have a brain job. I knew I had higher energy in

the mornings, so when I went to bed that night, I set the alarm for five thirty.

I rose in the dark, made coffee, stumbled to my desk, set a kitchen timer for sixty minutes, and told myself, Just do it for an hour. Then you can have breakfast. What I wrote that morning was not perfectly brilliant, as I had hoped, but it had more potential than the afternoon writing, and at the end of the hour, I felt good. I was beginning to answer my own prayers.

I would procrastinate and put writing on the back burner plenty more, but when I finally applied myself, writing early in the morning became my habit. It helps to get up earlier than my conscious mind, and I like writing first thing, when I am closest to my dream state. I also like to have it behind me when I face the demands of the day. Whatever I have on my calendar, however many houses I am scheduled to clean, I know I have taken care of the most important thing. I know I have taken care of my story and myself.

By the time *Life Without Water* was published in paperback, I was living in another cabin in a different part of the county. Jeri and Kathy started a book club and Jeri called me one day to say that they were going to read my novel. Could I come to the group, she asked. I told her that I would be happy to.

On the morning that the book club was scheduled to meet, Kathy called to tell me that the road had flooded. The water was receding, she said, and she thought I could get through.

Just drive slowly and remember where the ditches are. I packed my rubber boots, just in case.

I knew the water would be in the curve that dipped through the swamp, and I slowed down as I came to it. But the road was dry. There were stones along the shoulder, where the residents had marked the waterline as it rose. I could see, by the last stone I passed, that it had gotten pretty high.

I drove into my old driveway, plowed through a puddle, and turned to the right, toward Jeri and Kathy's house. Inside, six women were seated on the couch and in the BarcaLoungers. I sat in a chair close to the kitchen. I was sitting in the exact location where I had prayed to become a writer. Kathy poured me a glass of wine and handed me a plate of cookies dusted in powdered sugar. The powdered sugar drifted into my lap whenever I took a bite. Through a window behind one of the women, I could see the front yard and, beyond it, the road. A green truck drove by, a cloud of dust settling behind it. To my left, through another window, I could see my old garden. I still loved this place and I knew I always would.

I thought of one day, when Jeri came home for lunch while I was cleaning her house. We sat on the porch together and ate strawberries, pitching the caps over the railing into the azaleas. "What did you do with the foundation of my old house?" I suddenly asked.

"It's down there. We built around it. We wanted to use it,

but the building inspector wouldn't let us. You want to see it?"

We walked to the side of the house and Jeri unlatched the hasp to the access door. I knelt down beside her, and just inside, surrounded by Jeri's neat cinder-block foundation, was the wall of the foundation that had once supported my life. It was made of uneven rocks and I ran one finger along the hardened cords of cement that oozed between them. Jeri closed the access door and left soon after, but as soon as she was gone, I went back and opened the little door again and touched my old foundation.

I had never stopped touching that foundation. I had never stopped haunting this house. My relationship to it became more and more surreal over the years. By the time I was sitting in Jeri's living room, visiting with a book club that had read *Life Without Water*, my old house had become my own personal mirage, a shimmering image always just beyond my grasp.

I took a sip of my wine and a deep breath.

One of the women pushed her glasses up her nose and tilted her head to one side. "There's a fire at the center of this book," she said. "I was completely surprised by it. How did you get the idea for a fire?"

13

SPACE LUST

The Gunther house overlooked a ravine. Far below was a fast-running creek. On winter mornings, when I first arrived, the sun would be in just the right place to make the creek a ribbon of light winding through the woods.

The house was unusual. Instead of walls between the rooms, there were stairs leading up to different levels. A half-wall surrounded each level, so that you could lean over and look down into the living room. The effect was a feeling of indoor treehouses, one for each member of the family. This made the Gunther house difficult. I hauled my vacuum up to the master bedroom and then back down to the living room, and then up

to one of the kids' rooms and back down and then up again and back down again.

The countertops in the kitchen were covered in copper flashing, which had to be scrubbed with Zud and then wiped clean with a wet sponge and polished to a gleam with a dry rag. They looked great when I'd finished the job, but I knew the shine didn't last long. When she'd hired me, Mrs. Gunther had run her hand across the copper countertop and said, "It seemed like a good idea at the time."

They both worked in the hospital. He was a doctor and she was an administrator. They had two boys. I rarely saw any of them. The check was always on the long table just outside the kitchen. Sometimes Mrs. G left me a handful of candy and a note. "Please take these. The boys are eating too many sweets." The candy was always round, wrapped in gold foil, with a hazelnut center.

My favorite room was Dr. G's office. It was the smallest room in the house and was cantilevered on an exterior wall. Along three walls were wraparound windows surrounding a wraparound desk. The desk was honey-colored and buffed to a lustrous shine. I wanted that desk, and that much view, and that much uncluttered space. I lusted after the whole room. It would have made a great writing studio.

The only thing I didn't like was the bag Dr. Gunther had hanging up on one wall. After I dusted it many times, it finally

dawned on me that it had once been some poor creature's scrotum. It was the bristly short hair that covered the bag, and the crease that divided one ball from the other that finally clued me in. Don't get me wrong, I'd seen balls before, but none this size, and none hanging on the wall.

These would have been more than a handful had I handled them, but I didn't. I scooted past them with the duster as fast as I could. I figured the balls might have belonged to a bull. Poor guy, I thought. And then I wondered about karma, and how this might come back to haunt Dr. G.

Other than the bull's balls, I approved of Dr. Gunther's taste. He kept his office anally neat, which made it a pleasure to clean. His papers were stacked in a precisely arranged pile, squared off to the edge of the desk. His Cross pen sat parallel to his stack of papers. I gave a quick swish of the duster around his glazed pottery bowl full of paper clips, his one lamp, and his one picture of his wife. It was easy. No delicate breakables to worry over. No sticky notes adhering to the feathers of my duster. No precarious piles of papers that might tumble to the floor.

Really the guy didn't deserve that much desk. He could have worked on the narrow piece of plywood that was my desk at the time. It was wedged inside my closet and I could barely fit my legs under it. My manuscript pages had to be stacked on the shelf above. There wasn't even any room for a bowl of paper clips.

My desk was adequate. I could write there, but it wasn't my ideal situation, and as I dusted Dr. Gunther's desk, I looked out the windows and imagined his office as my office. I would have a dictionary, a thesaurus, and Strunk and White lined up to the left of my computer. And my manuscript would be stacked to the right, as neatly as Dr. Gunther's papers were. Then there was all the rest of the acreage of desk to put to use. I could stack other works in progress there. The many books I planned to write materialized in my imagination, and collated themselves along the lacquered wood of Dr. G's desk. And as long as I was playing this imagination game, I made my cat miraculously well-behaved and pictured her never lying on my papers again.

The best place I've ever written was a one-room apartment that was not much larger than Dr. Gunther's home office. The apartment was up high, with a view of the deep woods that ran behind it. Because of its size and its height, I dubbed it The Treehouse. It was the place I lived when I wrote the bulk of *Life Without Water*.

I remember having trouble with the name of the commune in *Life Without Water*. I had a list of names, none of which I liked and all of which I plugged into various places in my manuscript. There was Lazy Love, Chicken Ranch, The Haven, Butterfly Barn, and others that I can't remember. None of them felt right. And then one night I took my dog for a walk. The road

had several wicked curves in it, and I'd always noticed, driving home at night, that there was one particular place where the moon switched sides. Suddenly, along the dark road outside The Treehouse, the name of the commune came to me. Two Moons. It was perfect. I scribbled it down when I got home, and the next day I wrote into my novel a curvy driveway and a scene in which the commune is named.

I think this event, and the fact that I was so focused on my writing while living there, has imbued The Treehouse with creative energy for me. I've dreamed of going back to it and, instead of living there, using it as a writing studio. I've always thought it would be perfect. It's private, esthetically pleasing, has an indoor toilet, a small kitchen in which to brew a cup of tea, and a balcony to sit on while taking a break from writing.

I've written in a lot of different places: in the upstairs room of a rambling old mustard-colored farmhouse, in the loft of a tiny cabin that butted up against a state game land, on the Formica-topped table of a fourteen-foot travel trailer, in a converted closet, and on the kitchen table of a mobile home on a dairy farm, exchanging weekend milking shifts for free rent. Over time I've learned that writing is not so much about exterior space as it is about interior space, but the need of the interior drives writers to the exterior. The need of the interior drives us to seek "rooms of our own."

I am always looking for the place that is private and lonely.

Finding it takes a great deal of determination. While living in The Treehouse, I finally realized that if I really wanted to get this writing thing done, I would have to clear a path. I would have to slice a wedge of time out of a full pie of too many things to do: working multiple jobs, managing my own household, socializing, dating, and even reading. I already knew that getting up early in the morning to write was one tactic.

It's frustrating to search for the best way to fit writing into a busy life, and all the while the busy life keeps shifting and changing. New strategies have to be sought out and applied and discarded. Struggling against time and lack of solitude and the needs of a family are just part of writers' boot camp, keeping our prioritizing muscles pumped and toned.

I have known would-be writers who spent more time choosing flooring and drapery material for their new studios than they ever spent putting words on paper. Often a spouse, usually a doctor or a lawyer, is footing the bill. I'm envious as hell, even though I know in my heart that a beautiful, expensive space paid for by someone else would cause me a surefire case of writer's block.

Once I gave a reading at the Margaret Mitchell house in Atlanta. Before the reading I was taken on a private tour of Margaret Mitchell's apartment. The apartment was tiny, two rooms and a kitchen that was like an afterthought. She wrote *Gone with the Wind* in one corner of her living room. And be-

cause she didn't want anyone to know she was writing, she kept a towel draped across her typewriter when it wasn't in use. My guess is that Mitchell didn't want to be asked about her writing. It was private and she didn't want to discuss it. She was protecting her interior space, and therefore protecting her fledgling novel. It's hard to think of *Gone with the Wind* as ever having been a fledgling novel, but it was.

I sometimes fall into the trap of believing that no other writer has struggled with the issues I struggle with, when, in fact, every one of them has. Logically I know this. Yet emotionally I often imagine that my life is brutally crowded with too many things to do, while other writers relax on their verandas with glasses of iced tea and secretaries. It's telling that when I picture other writers, they are never writing. They are never sitting at their desks sweating under the weight of producing prose. They are never even sitting at their desks with words brilliantly flying from their fingers onto the page. When I picture other writers, I always see them with their writing behind them, as if I am the only writer that has to actually write. Poor me.

I forget that a writer can struggle with her prose and then go off to clean a toilet. Or a writer can struggle with her prose and then go off to face a freshmen comp class. Or a writer can struggle with her prose and then relax on the veranda with a glass of iced tea and a secretary.

There would also be days for all these writers when the planets are aligned and the muse has returned from her vacation in California and the prose is singing on the page, and even so, they have to tear themselves away from the desk to meet the demands of a life apart from writing.

Rebecca McClanahan, in the opening chapter of her wonderful book *Write Your Heart Out*, lists six misconceptions about writers. They are:

1. Writing gets done without writing.
2. Writers have time to write.
3. Writers know in advance where they are going and they get there.
4. Writers have something important to say.
5. Writers publish their work and get rich or famous or both.
6. Writers are smarter, more sensitive, and more creative than other people.

With all these misconceptions, it's no wonder so many people start writing and then quit. Writing is hard. Sometimes it takes a lot out of me, and sometimes I think it takes a lot out of the people I love, too, the people I want to respect it.

A writer needs a spouse who understands the vagaries of

her writing self. The ups and downs, the mediocrity, and the insecurity. A spouse who honors the need for quiet and space and privacy.

In my first marriage, as in my second, I wrote in the living room. I arranged a bookcase to block off the corner where my desk was. I stapled fabric on the back of the bookcase—the side facing the room—and filled the other side with books and papers and notebooks and jars of pens. It was visually private, my own sweet space. But none of this kept my first husband from reading my journal while I was at work one day. And none of it kept him from rolling his eyes whenever I mentioned poetry.

In the beginning of my second marriage, I wrote in the western corner of our one-room log cabin. There was no space in this house for visual privacy. The best I could do would have been to drape a towel across my desk, like Margaret Mitchell. Instead I used time as a curtain. I wrote early in the morning while Ben slept in the loft above. I was too intimidated to read my work out loud to myself. I was afraid that I would wake him. But except for this one detail, I did not lack for privacy. Ben would never invade my space or read anything I'd written without first being asked to. He would never roll his eyes. This, more than anything, is the writing space I've always lusted after.

But my dream of going back to The Treehouse has also come true. For years, whenever I ran into my ex-landlady, I'd ask about The Treehouse. She knew I wanted it for a studio, and twice it had been empty and available, but I hadn't been able to afford it. The third time she offered it to me, I said yes. I still didn't have the money, but it seemed so necessary, and I didn't want it to slip away again. Maybe I could clean an extra house or two, or maybe (dare I think it?) my writing could somehow pay for it.

At first, I didn't know what to do with The Treehouse. I was like the dog that caught the car. Bit by bit, I outfitted it with thrift-shop furniture, and once I had something to sit on, I would just sit and marvel at being there again. But I also felt divided, as if home and writing were two different things now, when they had always worked together before. Ultimately, I had to recognize that my writing life is everywhere. It happens at my desk at home, my desk in The Treehouse, and all the places in between that aren't desks. It even happens while I am down on my knees cleaning a toilet, or while I am vacuuming a Persian rug that doesn't belong to me, or scrubbing a granite countertop.

All of us have a certain amount of work we have to do to keep our lives afloat, and whatever work I choose to do, my writing life is there. Even with a room of my own, writing is not

a separate enterprise. It is not a jewel I keep in a velvet box and take out only when conditions are perfect. Writing is more like the yellow rubber gloves I pull on every day. I need my gloves to keep my hands from getting too dry. And I need my writing to keep my life and my mind moist and supple.

14

CLIPPING ALONG

Every other weekend I cleaned an office. The office was housed in a complex full of offices. I never understood the nature of the business that was conducted in the office, but here is what I do know. The carpet was blue and hard, without pile, and easy to vacuum. There was one bathroom, which consisted of a tall toilet and a sink. And there was a narrow strip of kitchen—a sink filled with scummy coffee cups, a small refrigerator filled with cans of soda, and a microwave that smelled like buttered popcorn. There were three private suites, two semiprivate suites, four cubicles, a boardroom, a storeroom, a copy machine, and a shredder.

Along every desk there was at least one family photo and beside it an array of personal items. The personal items included crackers and jars of salted nuts, fingernail polish and hand lotion, paintings of golf clubs, a framed one-hundred-dollar bill, a baseball, and a strip of magazine pictures showing Humvees in different colors.

Even though no one was in the office while I was cleaning, I felt out of place there. As soon as I had punched in the security code and hauled in my gear, I flung the windows open for fresh air. I couldn't wait to leave. I have never felt comfortable in an office, even while cleaning it.

I especially hate sitting in offices. If I find myself sitting in an office, it usually means I need something, like medical attention. While I wait, I look at phony décor and read outdated magazines beneath blinking fluorescent lights. Entering an office is like entering a sensory-deprivation tank but without the hallucinations, and the air is worse. I consider myself lucky that, except for cleaning, I have never had to work in one.

There was a lot to do in the office that I cleaned. There was trash to gather, boxes to break down, coffee cups to wash, the sink to swab, the smelly microwave, the counters, the toilet. I had to clean the office over the weekend and, because of this, I hated it even more. I also had to call ahead to let the boss know I was coming. This was the only way he might remember to cut me a check.

The trash was the worst and the best part of the office. It was the worst because there would be an average of twenty bags that needed hauling to the Dumpster. This was no easy feat. The Dumpster was at the back of the parking lot, hidden away behind a large wooden fence. Sometimes I made ten trips back and forth from the office to the Dumpster. This included stairs.

Clearly no one took the trash out during my absence and I had a difficult time respecting them for it. I don't believe that anyone is above trash removal, and I don't believe that it's unimportant. In fact I can't think of anything more important. And besides, taking one bag of trash to the Dumpster would have been a nice stroll away from the desk, a good excuse for fresh air. I couldn't understand why someone in the office wasn't jumping on this daily task. But from what I could tell, no one ever did. I always counted the bags and reported to Ben when I got home.

"Twenty bags today, and three armloads of cardboard."

"Fifteen bags. No cardboard."

"Twenty-five bags of trash and five loads of cardboard."

Sometimes dealing with the trash equaled half or more of the time I spent at the office.

But the perk in trash removal was seeing what folks threw away. Beneath each desk were a black plastic trash can and a recycling bin. The trash cans were full of candy wrappers, old envelopes, magazines, paper, microwave popcorn bags, sticky

soda cans, and, over time, a variety of useful items. The recycling bins were used as auxiliary trash cans, and full of exactly the same things.

The useful items I found in the office trash included a suit, several calendars, an unopened roll of wrapping paper, Christmas decorations, a stack of blank cards with matching envelopes, a working Palm Pilot, paper clips, and file folders. In the Dumpster I found a ladder, a plastic file box, a chair, and a dresser. I salvaged what I could and either used it or took it to the thrift shop.

My favorite finds of all were paper clips and file folders. There were plenty of each. The file folders were easy to scavenge. I just dumped the papers out and took the folders home. I ended up with far more file folders than I could use, so I took stacks of them to my writers' group and gave them away.

I had to work a little harder to get the paper clips. They were never just lying in the bottom of the trash where I could scoop them up. Instead they were always clasped around the paper in the discarded files.

There was a paper clip bowl sitting on each desk. I could have returned the paper clips, but I never did. As far as I was concerned, if I did the work of removing them, they were mine. I scored an average of twenty to thirty paper clips each month. They were nice big ones, too. I haven't cleaned the office for three years, but I am still using their paper clips.

But my supply is dwindling now. It's dwindling because I am submitting my work. This is a change for me. In the past I've avoided submitting, knowing it could and would lead to rejection. It has, but it has also led to publication. I'm always excited when a piece of mine is accepted, but whatever response I receive, acceptance or rejection, I try to remain detached about it. I try to retain a systematic approach to submitting, but I'd rather be writing. Twice a month I gather my finished work up, research the markets, read the guidelines, and address the envelopes. Then I go to the post office and mail them, not forgetting to add the postage to the self-addressed envelopes inside.

My favorite part of the process is my submissions chart. Even though I don't like offices, I do like charts, and I've made one to track the travels of my work. My submissions chart is in my spiral notebook with the words "Lunch Ladies Rock" printed on the outside. There are six columns. One for the title, one for the place I send it, one for the date I send it, one for the date on which I expect a reply, and one for yes or no. The last column is for comments. After I've recorded my submission, I close the book and try to forget about it. I move on to other things. I write more, send out more work, and vow over and over again that I won't get depressed if it is rejected.

I got a short story back last Monday. It was in the mailbox when I got home from cleaning a house. The brown manila envelope with my address on it, written in my hand, could mean

only one thing. I couldn't remember which story I had sent to this particular magazine. It turned out to be one of my favorites, about a young girl who befriends the homeless woman who has moved into her secret playhouse in the woods. I love the story, but so far I cannot sell it. The rejection note informed me that this work "currently does not meet our needs." Okay, okay, I told myself. This is not a crisis. Keep moving. This is just a rejection of my work. No big deal. Don't stop writing. Don't get depressed. Just focus on the next task.

The next task was recording the return of my manuscript in my notebook, so I opened it, found the submission, and in the column that required a yes or a no, I wrote, "No," and closed the book. I'm going to kill them with numbers, I told myself. For every one submission I receive back, I'll send out two. This seemed like a good plan, but before I could execute it, I got another story back and then another and another. I got four in one week. All of them were unable to meet someone's current needs.

I love the "current needs" line and am thinking of adopting it as my own every time I am asked to do something I don't want to do.

"I'm sorry. Your offer to give generously to the Republican Party does not currently meet my needs."

"I'm sorry. Your offer to participate in a telemarketing survey while I am in the midst of fixing dinner does not currently meet my needs."

It would work for anything. You could even use it to turn down dates.

"I'm sorry. Your offer to go to the Monster Truck Rally does not currently meet my needs."

It's fun to say but not so much fun to hear. My needs now included sending out eight submissions. The trouble was I didn't have time. I wanted to rewrite two of the stories that came back to me, but I was hard at work on something else, a larger piece with a momentum that I didn't want to break. Then three more manuscripts were returned and now I was behind by fourteen.

I noticed that every one of these last three manuscripts had been returned to me without its paper clip. Until then I had been working hard at not admitting that I was discouraged, but the missing paper clips tipped me over the edge. It was easier to concentrate on their loss rather than the rejections. They had been the nice big paper clips that I had gleaned from the office trash cans. I stacked my returned short stories on one edge of my desk and stirred my finger in my bowl of paper clips. It was mostly filled with small ones now. Bad enough to have needs that I cannot currently fill, but to take my paper clips too! "I'm sorry, your work does not currently meet our needs, but your paper clips do."

My writer friends and I are pathetically excited when we get what is called a "good rejection." This is a rejection that basically says, "We liked your story. We found it well written,

original, and interesting, and just to prove it, we're not going to publish it." The needs line is always cited as the reason. You should hear us on the phone reading our little rejections back and forth to each other.

When I think about it, none of it makes any sense. Why should I sacrifice my postage and envelopes and paper and paper clips to the nebulous world of submissions? On the other hand, why should I quit?

Well, there are a million good reasons to quit and only one good reason to continue. The one good reason is me. This is what I want. I like writing stories and I would like it even better if people read them.

On the day that I noticed my paper clips missing, I took back my vow of submitting two manuscripts for every one returned. I made a new vow, just to keep writing and working on submissions twice a month. I opened my notebook and recorded the rejections of these last three manuscripts. In the comments column I wrote, "Took my paper clip." And then, to remind myself to keep a sense of humor, I opened my notebook to the inside of the cover and wrote, "Send out your stories. There are editors in New York that need the paper clips." I closed my notebook and ran my finger over the words "Lunch Ladies Rock."

15

DUST TO DUST

The Websters lived in a condo. There was a bay window in front and a kitchen in back. Upstairs were two bedrooms and a full bath. Downstairs were the living room, a dining room, and a half-bath. The floors were covered with plush, cream-colored carpet. It was like freshly fallen snow. A tracker's dream. A housecleaner's nightmare. Every footprint showed.

The dining room was filled with a gleaming mahogany table. It was too large for the space and was crammed between two credenzas, a silver tea service sitting on one and a vase of hideous silk flowers on the other.

In the living room there was a couch, which no one ever sat

on, and two wingback chairs covered in cream-colored uphol-
stery with gaggles of miniature geese flying in formation from
one side to the other. Between the chairs was a small table filled
with cloisonné pillboxes. Mrs. Webster sat in the wingback chair
to the left of the pillboxes while Mr. Webster sat on a straight-
back chair pulled just outside the doorway of the kitchen. That
is, when he sat at all. Mostly he kept moving, bringing whatever
it was that Mrs. Webster was calling for.

One day I was cleaning the cloisonné pillboxes while Mr.
Webster rumbled around in the kitchen, making his wife a ham
sandwich on white bread with mayonnaise and yellow mustard,
because, she said, she didn't like that brown kind. While Mr.
Webster worked and I worked, Mrs. Webster tucked her feet in,
out of my way, and sighed. "I'm eighty-three years old," she said,
"and I've been waiting to die since I was forty-five."

I picked up a pillbox shaped like a woman's hat and ran my
rag along the brim. It was a dilemma of manners how to reply
to Mrs. Webster. It didn't seem right to commiserate with her
on the exceptionally long wait, but I didn't think she wanted to
be reassured that death wasn't just around the corner. I simply
said, "Wow," and put the hat pillbox down and picked up one
shaped like a schnauzer.

Mrs. Webster dressed to the nines every morning. I never
saw her wearing anything other than a neatly pressed blouse
buttoned tightly to her warbly throat and a neatly pressed skirt,

which she constantly smoothed with her soft, dimpled hands. She wore hose and shoes with chunky heels. She always had her makeup on and her teeth in. When Mrs. Webster wasn't smoothing her skirt, she was peering into the tiny mirror of her compact and touching her face with her fingers. The compact was kept in her purse, which was always at her side, if not in her lap. She was ready to go somewhere—heaven, she thought—but I wasn't sure. What would God have to say about suddenly stopping everything and waiting to die for thirty-eight years?

After I'd finished with the cloisonné pillboxes, I plucked my feather duster out of my back pocket and gave the top of the table a quick flip. It was hard not to flip the feathers right across Mrs. Webster herself. She was such a fixture in that chair, a big powdery doll waiting to be played with at the funeral home. She looked sturdy enough to me. It was Mr. Webster who looked like he might collapse any day now.

He was skinny and bony and bent, and his life was also built on waiting, waiting on Mrs. Webster hand and foot. She kept him scampering with her heavy sighs and constant throat-clearing, her detailed directions regarding sandwiches, and her schedule of pills and appointments with hairdressers and doctors. I was grateful for the appointments. It meant that Mrs. Webster was not always sitting in the wingback chair waiting to die as I dusted the cloisonné pillboxes and vacuumed.

The Websters had two parking spaces reserved outside their

condo. Their burgundy Lincoln Town Car was kept in one and the other was left empty for the paramedics who would surely be arriving any minute now. I was not allowed to park in that space. Instead I had to pull up to the curb and unload my gear. Then I had to move my truck down a hill, park in visitor parking, and hike back up the hill for work. At the end of the day the procedure was reversed. At the time, I was driving my old orange Datsun truck. It was ten years old and the only vehicle I had ever owned. It was beat up and dinged and it ran like a top.

One day Mrs. Webster had a doctor's appointment. It was an ordeal getting her out the door. First Mr. Webster moved the Lincoln eight feet from the parking space to the curb. He left it running while he came back inside to gather Mrs. Webster.

"Is the heater on?" she asked, smoothing her skirt.

"It's May," he answered. "It's warm outside."

"I don't want to be cold," she said. Her hands fluttered to her lap and nestled there like little birds.

Mr. Webster went back outside to turn the heater on in the car. It was a beautiful day outside, but inside it was stuffy and hot. I couldn't wait for the Websters to leave so I could cut the heat down and fling a few windows open, but during the time that Mr. Webster was gone Mrs. Webster discovered a stain on her blouse. "Oh dear," she said.

Nobody wanted Mrs. Webster to go to heaven or the doc-

tor's office with a stain on her blouse, and no one wanted her to have to climb those stairs again, so she described the blouse she wanted and Mr. Webster went to fetch it. "It's the blue one," she said. He returned with a blue blouse on a hanger. "No," she said. "The blue one." Mr. Webster looked at the blouse on its hanger and shrugged. He went back upstairs and brought down another blue blouse. It too was wrong. "The blue one," she kept saying.

"Oh, the blue one," he said as he trekked back upstairs and then back down, a shirt on a hanger and a question mark on his face.

"Honestly," Mrs. Webster said. "The blue one."

At last he brought down the correct blue blouse and he shuffled Mrs. Webster into the downstairs bathroom where they got her changed and smoothed again. Mr. Webster then helped her out to the car. I breathed a sigh of relief, but then I heard the front door creaking open again. It was Mr. Webster coming back in for Mrs. Webster's purse.

I glanced out the window. She was sitting in the front seat of the car, staring straight ahead. I plumped the pillow on Mrs. Webster's chair and thought of the irony of dying in something called a wingback. Her skirt would be smooth and her blouse without stains. She would have her purse, her makeup, her teeth, and maybe even her wings. You couldn't fault her on preparedness.

They finally pulled away from the curb. I turned down the thermostat and opened the windows. I heard a woman's voice coming from the parking lot, saying, "I'll find out who owns it. I'll take a hammer to it."

That was interesting enough to check out, so I went to the front of the house and looked out the screen door, to the right and then to the left. In the lower forty, where I was allowed to park, there was a man changing the license plate on one of the cars next to mine. There was also a tall, skinny woman dressed in a navy blue suit with blue-black helmet-hair that almost matched. She was marching up the hill. When she got in front of the Websters' condo, she saw me standing in the doorway. "Is that your truck?" she asked, pointing a lacquered nail toward my Datsun.

"Yes, ma'am," I said.

"You get your keys right now and come out here," she demanded. "You have scratched my car with the door of your truck."

"Okay," I said. She's a little rude, I thought, but I plunged my hand into my bag and dug out my keys anyway. As I followed her down the hill to my truck, I tried to remember if I'd hit someone's car while getting out. It didn't seem like it. I couldn't even remember a tight squeeze.

The man who had been putting his license plate on was finished with the job now and he stood to the side, looking

amused. The tall woman pointed to a scratch on her Mercedes. It was about an inch long. "It might not look like much to you," she said. "But this is a brand-new car and I have been very careful with it. I know that scratch wasn't there when I parked last night."

I could see right away that the door of my truck wasn't going to come close to her car. I gauged it to clear by six inches and I told her so.

"Well, we'll just see about that," she said.

"Yes, we will," I replied.

I unlocked my truck and opened the door. It cleared her car exactly as I had predicted. I wished I had a tape measure. "Well," she said. She pulled a pad of paper and pen from her pocketbook and walked to the back of my truck, where she began writing down my license plate number. This was too much.

"Ma'am, do you continue to think that my truck door scratched your car?" I asked.

"I just need to know who you are," she said.

"I'll tell you who I am. I'm Nancy Peacock and I clean the Websters' condo. And who the hell are you?"

"I am Miss Bentworth."

"I didn't hit your car," I said. I pointed to the man who had been changing his license plate. "You're a witness," I told him. He looked as if he would burst out laughing. I locked my truck and left.

When the Websters came home, I told them about the incident. Mrs. Webster settled into her wingback chair, smoothed her skirt, and said, "She's a PhD," as if that explained everything.

Well, she needs to buy some fucking vowels, I thought.

Nothing ever came of it. I never heard from Miss Bentworth or her lawyer or her insurance agent. But now that I knew who she was, I saw her everywhere. I saw her in the grocery store perusing the frozen dinners. I saw her having a latte at my favorite milkshake café. I saw her parking her Mercedes on campus while I walked to the library. She never saw me. Or if she did she didn't recognize me. Or if she recognized me she never acknowledged it. But of course she wouldn't. If I had acted that way, I would want to put the whole thing behind me too.

Years later, after *Life Without Water* was published and while I was still working in the high-end grocery store, Miss Bentworth came in and stood at the deli counter. She looked the same, still dressed in a navy blue suit, still with stiffly sprayed blue-black hair.

"May I help you?" I asked.

"I believe he was here first," she said, pointing to a child I had not been able to see because of the height of the counter. This elevated my opinion of Miss Bentworth. A lot of customers ignored children who were there in front of them, and I literally

could not see anyone who was under five feet tall. The child ordered a chocolate chip cookie. Miss Bentworth wanted a tub of the curried tuna, a tub of coleslaw, some smoked mozzarella salad, and a breast of the rosemary chicken.

"Thank you," Miss Bentworth said.

"You're welcome," I answered.

By this time I'd sold my old orange Datsun truck and bought a Honda Civic. The Civic was blue, and even more beat-up than the truck had been. But it had a hundred thousand fewer miles on it and it ran great. I paid five hundred dollars for it.

I was cleaning the house of my mechanic and his family and one day he looked at my vacuum cleaner, a Miele, and said, "We thought about buying one of those, but it was kind of expensive. Damn, Nancy, you spent more money on your vacuum cleaner than you did on your car."

"I spend more time with my vacuum cleaner," I said.

Cars have never much interested me. If a car is reliable, I love it. If it is not reliable, I hate it. Whether it's shiny or not doesn't matter to me. And besides, on a writer's salary or a housecleaner's salary or even both combined, it wouldn't make financial sense to seek out a car payment.

I was always worrying about money, or the lack of it. In the midst of my dual career, I was beginning to think that I would be cleaning houses forever and that I would never be a belle of letters. My vision of sitting every day in a beautiful room,

musing brilliantly while the rest of the world went to work in their shiny new cars, was totaled.

I'd tried a lot of different kinds of writing over the years, and one of the pieces I had actually been paid for was titled "I Poisoned My Mother," which I sold for one hundred fifty dollars to a confession magazine. I had to sign a piece of paper saying that my piece was true, or based on truth. It wasn't, but I signed.

I wondered now if I could do that again. Maybe I could write and get paid for two confessions a week. I could live off that. It was a long shot and one that I wasn't particularly excited about. Writing "I Poisoned My Mother" had been excruciating. Instead of going to my desk with my cup of coffee every morning, I'd gone back to bed and read a confession from the stack of magazines I'd bought at the newsstand. Then I took up my yellow legal pad and in longhand emulated the style. It took me a week to finish it. I sold it right away but wasn't paid until five months later, when it was published. Meanwhile I'd received a rejection on my second attempt at confessions.

But I was at that stage again with housecleaning where I was not seeing the advantages. It felt like a trap of endless backaches and toilets and steady money. Maybe I could just give up my "highbrow" writing career and cross over to the dark side. After all, I had been featured in the *National Enquirer*.

So I went to the newsstand again and picked up six confes-

sion magazines and a copy of *Poets and Writers*. "This is quite a combination," the guy at the register said.

"I'm a Gemini," I told him.

Out in the parking lot I sat in the seat of my beat-up Honda Civic and flipped through the *Poets and Writers*. I was parked next to a Mercedes, but I didn't notice this until a man came out of the newsstand and unlocked the car and got in. I recognized the man as a local well-known writer. He was a literary success. His books were interesting and readable. They were not schmaltz. They were good books, and here he was, driving a Mercedes while I sat in my five-hundred-dollar Honda Civic with a stack of confession magazines sliding off its ripped seat. I did not find comfort in this fact.

He felt my stare and turned to look at me. What is your problem? his eyes said. I looked away and he drove off. I'd embarrassed myself now. If I ever met him at a literary function, if I ever got to go to another literary function, he would remember me as the chick in the beat-up blue Honda Civic, who was staring at him outside the newsstand that day. Weren't those confession magazines sliding onto the floorboard? I could only hope that his memory was as bad as Miss Bentworth's.

I went home and read one of the confession magazines cover to cover. With the exception of a story that involved duct tape and homeland security, which I loved, it was pretty dismal.

It was as dismal as the smell of wet rags in my cheap car. And I realized I still hungered for at least one more literary work, even if it meant writing part-time while continuing to clean houses.

I don't know whether Mrs. Webster has died yet or is still waiting. I replaced that job as soon as I could. I know that when I think about dying I never feel ready. When I am in the midst of writing a book I'm always a little on edge about it. What if my time comes before I'm finished? What would become of my characters? It wouldn't be just my death. It would be theirs too, and maybe it only matters to me, but it matters a great deal to me.

It's been said that all writers write in order to escape death. I began writing primarily because I wanted to leave something of myself behind, but I also wanted money. I wanted fame and a fat bank account. I wasn't looking to have a chauffeur but I did want a good car, one that never broke down. But that's a fantasy too. Sooner or later cars always break down.

The best car I ever drove was an old sixties car, painted pink, with fins. I did not drive this car in the material world. In a dream I had one night, I was driving Big Pink through the countryside. I was passing rolling hills and green meadows when she stopped running. I got out and opened the hood. I don't know anything about cars, but it seemed like the thing to do. One thing I did know was that there was supposed to be an engine in there, but there wasn't. This was too much to think

about. I needed to sleep on the problem. There was a hotel close by and I rented a room and spent the night. When I went out to my car the next morning, I decided what the hell, I'd give it a try. I put the key in the ignition and turned it. The car roared to life and I drove off. I didn't question why it worked. It worked and that was good enough for me.

Maybe I needed to look at my housecleaning and writing life that way too. Maybe I needed to stop checking under the hood. Maybe I just needed to turn the key and drive.

16

QUITTING

I cleaned houses professionally for fifteen years, and I have been writing for forty-two. I have quit both so many times it's not funny. When I've quit housecleaning, I have tended to do it impulsively and have gone cold turkey. Once I decided to quit while driving home after work. I knew I was approaching a roadside Dumpster, and when I got there I pulled over and stopped and threw away all my supplies, everything except the vacuum cleaner.

My kit's spray bottles fell like bombs and my rags hovered in the air like an invading army of parachutists. But what I

remember most vividly is chucking my mop like a spear and the way the strings streaked behind it like the long hair of a woman on a motorcycle. I drove away feeling light and naked, as if I'd just broken the spell of a bad relationship. The next day I called all my clients and told some of them that my knees were giving out and I needed to quit. When I got tired of that excuse I told the rest of them that I needed to spend more time on my writing. When I was done, I went to my desk, sat down, and waited for brilliance, but brilliance did not come.

Nor did it come the next day or the day after. I waited a month for brilliance and each day I became more and more panicked. And soon brilliance didn't matter at all, because my bank account had become decidedly unbrilliant, and my hierarchy of needs, like everyone else's, demanded food and shelter.

I combed the help wanted ads. There were lots of openings for "team players," but I was pretty sure that didn't mean me. There were also openings for people who were "self-motivated," but because my self-motivation tended more toward self than anyone else, I thought this too was a bad idea. I knew that even low-paying service jobs demanded pretend loyalty, and I knew that I wouldn't be able to stomach it.

A friend of mine, another writer, worked as a barista in a gourmet food shop, and every morning before the restaurant

opened he and the staff had to stand in a circle and recite memorized lines regarding their creed of excellence and service.

I always hated to have words put in my mouth. That's what public school was for, and I'd done my time there. All I wanted now was a job where I could show up, work, and go home with a paycheck. Oddly, this made me practically unemployable. Finally I gave up and called the paper to place my usual housecleaning ad. Within a few weeks I was working the same job I'd quit, with a whole new client base.

I tend to the extreme whenever I quit writing too. It usually comes in the murky middle of a book. Somewhere in the second or third draft that still reads like a first draft, I start to ask myself, "Why? Why are you doing this?" For a while it seemed as though the more I wrote the less I knew the answer. Fame and glory had eluded me. I could not live off my royalties and I'd already fulfilled my bit for posterity. Like Mrs. Webster, it seemed as if I could wait to die now. Unlike Mrs. Webster, I thought I should have some fun while I waited. Suddenly one morning I was done with it. I told my husband, "I've quit writing."

He smiled knowingly. "Okay," he said.

"No really. I've quit. It's over. I mean it this time."

"Okay. That's fine."

"I'm going to weave instead," I announced.

"Okay," Ben said. "But I think writing's in your blood."

"It's not," I told him. "It's not in my blood. I don't have to do it if I don't want to."

"It's your choice," Ben answered.

That's right, I told myself. It's my choice. I'm a grown-up and I don't have to do it.

For a month I got up early every morning and instead of going to my desk, trying to untangle the problems of a manuscript, I went to the couch and wove tapestries on homemade cardboard looms. And I loved it. I was really happy.

"I'm really happy," I told Ben.

"Good," he said.

I churned out little coasters, and mats, and useless things to hang on the wall. I checked out books from the library about weaving and I measured one corner of the living room to see if I could fit a tapestry loom there. I found that I could, if I got rid of my desk.

But I didn't get rid of my desk. I never chunked my computer into the Dumpster the way I did my mop. And I never went to the meetings of a local weavers' group, because they met on Wednesday evenings and that was the night my writers' group met.

I complained every Wednesday. I didn't want to go. There

was no point in it. I should quit. I wasn't producing. It was too long a drive. I wasn't writing anymore. I'd given it up. Even so, I kept going, and I didn't get rid of my desk, but I did continue to Google "looms" on the Internet.

Then one morning I got up and instead of weaving I sat on the couch with my notebook and my Shaeffer cartridge pen and I wrote. I wrote not to be productive or because I had something to say but because I liked it and had missed it. I had especially missed the feel of the pen in my hand.

Julia Cameron, in *The Right to Write*, calls this "hanging out on the page," and I love to do it. It's like hanging out with your lover. If that relationship becomes all about managing the household and the kids and the busy schedules, you lose touch with each other. You need to hang out again. When writing became all about my alleged career, I lost touch with it and I wanted to leave. I needed to hang out on the page again. And after doing so for a while, I went to my desk one morning and turned the computer on and opened a file.

"I'm writing again," I told Ben.

"I thought so," he said.

Ben has the good sense to never say, "I told you so," no matter how many times we go through this. And we've gone through it a lot, because I am a serial quitter. Like an alcoholic, I need to put this statement in the present tense. I don't think

I'm cured. I could quit again when the going gets tough. I know I'll feel the urge.

But quitting exacts a price, not just on my writing but also on my soul. When I can't give my soul what it needs through writing, I go off in search of some other bright ball of yarn. And what I need to learn is that I don't have to be so extreme. When my soul yearns for the tactile, it's okay to weave. In fact it's a good thing for a writer to be nonverbal for a while. It's a big lesson for me to learn that being a writer shouldn't mean that I'm chained to my desk twenty-four-seven.

Another big lesson is to finally understand that once I am a published writer I will always be a published writer, but that I will also always be an unpublished writer. I will get rejection slips, no matter what the *New York Times* said about my first novel. And hopefully I will always have material in need of some work, because if I don't have the pages I hate I will never have the pages I love.

I feel like my writing life is finally in a good place and that I can honor both my writing and whatever I have to do in order to live. I struggled for years to accept myself as both a writer and a housecleaner, and to be open about both.

For a while I became fiercely defensive about housecleaning. Sometimes I even claimed to love it, and all along there have been things I really liked about it. I've always preferred it

to any retail job. After all, who could be more self-motivated and less of a team player than a housecleaner? Or a writer? Or a combination of the two?

But over the years, housecleaning started wearing thin, as did my joints, most notably my back and my knees. Besides being in pain, I also hated the way my car smelled of Citra-Solv and wet rags. Surely, I told myself, you can do better than this. I knew I needed to quit again, but this time I needed to quit sanely and perhaps finally. I needed to whittle my jobs down one by one rather than stopping at the first available Dumpster and chunking my whole livelihood into its grimy darkness. I needed to replace housecleaning, and writing was the only other semi-marketable thing that I knew how to do. I started exploring teaching.

I'd always been frightened of teaching. For one thing, I had no credentials other than a couple of published novels. For another, I've had to feel my way through the inky shadows of everything I ever wrote. I knew from being interviewed that people were prone to asking questions as if I might have answers. And I'd heard interviews with other writers who actually claimed to know what they were doing. I didn't feel that I had answers or knew what I was doing, so what right did I have to pretend that I did? If I taught I was going to have to share my insecurities and vulnerabilities around writing.

Even greater than those worries was the fear of other people's words. I was afraid that if I began dealing too much with other people's manuscripts and stories that they would swallow my own. I didn't want to increase the fragility of my writing life, but I needed to do something.

I started off with a class called Prompt Writing. I pitched it to a local Borders and they accepted my offer, agreeing to pay me fifty dollars for each session. I wanted the class to be free and open to the public. I wanted people to just drop in, as they needed it. I wanted it to be fluid. I would provide prompts to write from, a timer to tell us when to stop writing, and instructions to keep your pen moving no matter what. And hopefully I would also provide a safe environment, encouragement, and fun. The first time I taught this class I sat in the parking lot beforehand saying a prayer. "Please God, let me get through this."

What the hell kind of prayer is that, I scolded myself. Get through it? You can get through it without God. What is it you really want?

"Please God, let me do really well with this. Let this be a great class. Let people want to come back. Let it be a success. And please be with me."

Another answered prayer. Although we've changed locations, Prompt Writing is still going strong after three years. Over time I added more classes, first a class on developing a

writing practice, then a critiquing class, and now two ongoing writers' groups that are held in my studio, The Treehouse. And as I added income, I also whittled away at my housecleaning schedule. Bit by bit I left it. I used fewer and fewer rags and went through less Citra-Solv. It took longer for my mop head to wear out, and I didn't spend so much money dropping by the vacuum-cleaner store to buy their overpriced bags.

But the best part is that I am not overwhelmed or swallowed up by other people's words. I like their words. I love their words. And I love being around other writers. I need to be around their enthusiasm and tenaciousness. I need their support as much as they need mine.

Oddly enough, one of the things that was most difficult about this transition has had to do with identity. Who was I if I wasn't cleaning houses for a living? Was I a writer? It was a scary statement to make. So many other times I had claimed to be a writer, and felt challenged on the point. Either I wasn't published, or else I wasn't published enough to be making a living at it.

I think this is the reason I held on to one house after having quit all the others. It was an easy house, one story, two baths, with bright sunlight pouring into the kitchen. There were also two kitties, whom I liked to love up on, and my client, who worked at home. Sometimes when you clean someone's house, you become friends with them. This is what happened to Joy and me. We got close, and every day opened with a hug, and

closed with a hug. Somehow, I just couldn't bring myself to quit Joy's house.

In cases like this, my body often takes over and tells me what's best. It became clear, after I sprained my back again while moving a file cabinet up to The Treehouse, that cleaning houses for anyone else but myself was no longer an option. Even though the injury had not occurred while I was cleaning, I knew I had a weak back, and I knew I was compromising it. I'd cleaned my last house without even knowing it was my last house. I called Joy and gave her the news. I also gave her the name and phone number of one of my students, who was looking for work. Now Lucinda cleans Joy's house, and keeps up with her writing by getting up early in the morning. The official passing of the mop has taken place.

After my back healed, I went out to my car, popped the trunk open, and dragged out my gear. I called Ben to come see as I tossed my old toilet brush into the trash can. It had seen a lot of toilets. Its bristles were worn down to a nub, and I had been meaning to replace it but hadn't been able to bring myself to. Spending money on a new toilet brush, even though it wouldn't have cost a lot, would have felt like failure to me. It would have felt like I was admitting that this is my job, this is what I do. I realize now that I was living betwixt and between, unable to replace my toilet brush but also unable to completely give up housecleaning.

I don't miss it. I don't miss it at all. What I had been missing all those years was cleaning my own home. I'd forgotten the rhythms of housecleaning and now I've rediscovered them. I've rediscovered that I can vacuum in the time it takes Ben to drive up the street and get Mexican food to go. I can sweep between vacuumings, and I've finally got a handle on those dust bunnies. The bathroom gets swabbed before it reaches critical mass, and the kitchen counters get wiped down while Ben washes the dishes. And every now and then I walk through with a feather duster and knock the spiderwebs down. I'd forgotten how much I actually love taking care of my own home.

This week I turned my cleaning talents to my studio and to organizing my desk. It was hard to make sense of all the randomly produced papers, newspaper clippings, and ideas jotted down on the backs of envelopes pulled from my clients' trash cans. There were also recorded dreams, pictures and quotes that had caught my eye, names of characters, names of streets, and names of invented but undeveloped towns.

I gathered it all together and sorted it out. Quotes went into a notebook. I started a picture file and a clippings file. Notebooks full of prompt writings went into a basket on my bookshelf. Ideas, character names, place names, and street names all went on index cards tucked into a plastic file box. What trea-

sure! I felt excited as I worked. There is so much I want to do. There is a collection of short stories I need to finish, a novella I want to write, an idea for a children's book, another idea for a novel, and then there is that book of essays about housecleaning and writing. I really must get to that.

About the author

About the book

Read on

Insights,
Interviews
& More . . .

An Interview with Nancy Peacock

How did you start writing? Are you one of those people who knew from childhood that you wanted to be a writer?

My fourth-grade teacher introduced me to creative writing. Prior to that I read a lot of novels, but I don't think I really had any idea of where books came from. Every novel I read was a complete world. The characters were real to me. The situations, the settings, the problems were more real to me than movies or TV.

It did not decrease the magic of reading to know that books were written by real people. I think it actually enhanced the magic to think that I might grow up and become a person with my name on a book.

Writing became my hobby after that. As a child I liked to watch TV shows, steal the plots, and write them into stories. I think this was a good exercise for me. I think it helped me to learn about beginning, middle, and end. I don't recommend it as an exercise now, as I think the quality of television has gone downhill. There is less character-driven action now, and more just plain action—violence, car chases, sensationalism.

I pursued writing all throughout

public school. My problem after high school graduation was the problem we all face—how to be an artist while earning a living.

You mention in the book that once, while on a speaking tour, you told the audience that that you never went to college. Why was it important for you to let them know that?

It was important because I wanted to be known for who I really was, not for who people assumed I was. While on my first book tour I was surprised at how many people I met who assumed I was affiliated with a university. Not just a college graduate, but a professor. It had never occurred to me than only professors could write books, but it had never occurred to many of the people I met that a woman who never went to college and who cleaned houses for a living could also write a book. I spoke publicly about it only because I felt uncomfortable. I felt that if I didn't open up about this part of my life then I was being cagey and actively hiding something. The act of writing means that you have to know yourself, and I couldn't know myself and hide myself at the same time.

You've had a number of interesting jobs, housecleaning being just one of them. Which was your favorite, and which ▶

66 It did not decrease the magic of reading to know that books were written by real people. I think it actually enhanced the magic to think that I might grow up and become a person with my name on a book. 99

did you hate the most? If you weren't a writer, what would be your ideal job?

My favorite job is the job that I have now: teacher. I love running workshops in my studio and working with my students. Beginning writers have a tenacity that is awesome, and I like being around people who are involved in the process, and I like watching them grow as writers. I can only hope that my students learn as much from me as I learn from them. And that I am as inspiring to them as they are to me.

The job I hated the most . . . that's a hard one. Probably cocktail waitress. I didn't mind being behind the bar, but I didn't like being out in the crowd balancing a tray of drinks and getting rubbed up against and called Baby.

I can't think of an ideal job. Every job is hard.

What inspired you to write A Broom of One's Own?

I was actually at a low point with my writing. I'd just finished writing a book that I wasn't satisfied with. I'd given it to my agent, but it wasn't selling, which only depressed me. I knew I needed to move on from it and write something new, but I was at a loss as to what that might be. I was

66 My favorite job is the job that I have now: teacher. . . . Beginning writers have a tenacity that is awesome. 99

4

whining about this to a friend who was a member of my writer's group and who also attended my Prompt Writing classes, then held at Borders. She had heard a lot about my timed writings and had noticed that I often wrote about the houses I cleaned. She punched me lightly on the arm and said, "Why don't you write about housecleaning?" I thought about it, and the next day I wrote "Enquiring Minds" and launched *Broom*.

I decided on the structure of beginning with a house I had once cleaned and moving the narrative toward my life as a writer. I wrote each essay in longhand, then transferred it to the computer and worked on revision. I completed about one essay each week. I had a lot of fun revisiting the houses I'd cleaned. In fact, I had a lot more fun writing about them than I'd ever had cleaning them.

Your two previous books were novels, but this one is nonfiction and partly a memoir. Do you find the process of writing nonfiction very different from writing fiction? Was it difficult to reveal so many personal things about your life? How about other people's lives?

I think the process is very different, depending on what you are writing. ▶

> " I had a lot of fun revisiting the houses I'd cleaned. In fact, I had a lot more fun writing about them than I'd ever had cleaning them. "

I did not feel that writing *Broom* was especially revealing, so I didn't feel exposed or worried while I was working on it. I was just a woman with a job, and that seemed admirable, rather than something to be ashamed of.

I worried a little about writing about other people, but honestly, if you don't want your maid talking ill of you, you really ought to flush the toilet!

In your book you talk a lot about what people think writers should do or achieve, and how damaging that can be. What do you think is the biggest myth out there that people have about writers? Or that writers have about themselves?

Good question. I think the biggest myth that the public at large has about writers is probably that we have lots of free time and loads of money.

I think the biggest myth that writers might have about themselves is that we're somehow more important than we really are. I always cringe a little when I hear a writer say that it's our duty to make social commentary, expose social injustice, etc. I don't think it's my duty at all. My duty as a writer is to tell a good story, and to tell it well. If I'm faithful to my characters

❝ I worried a little about writing about other people, but honestly, if you don't want your maid talking ill of you, you really ought to flush the toilet! ❞

first and foremost, then it often happens that some sort of social commentary occurs. But honestly, if it doesn't, it doesn't. It's not my job to be lofty, or to somehow "have my finger on the pulse of the nation." I'm just a writer, a modern-day storyteller. If I thought I was anything more, I'd get frightened and completely shut down.

What are some of your favorite books and writers? Who have you been influenced by?

My favorite books in the whole world are the Little House books by Laura Ingalls Wilder. I read all her books as a child. Later, when I was twenty-five and my father was dying of leukemia, I went to visit him one day in the hospital and I found him propped up in bed with a huge stack of books. I asked him what he was doing, and he said he was rereading all his favorite books, starting with his old McGuffey's Readers and working his way to Tolkien's trilogy, which he read every winter. This was how my father was facing his pending death—by revisiting literature. I was very sad that my father was sick, and I had my own grief to face. But he inspired me. I went home that night and began to reread all the Little House books, and I was completely impressed by ▸

them. Not only was I impressed, I was also comforted. These were books that my father had read to me when I was curled in his lap. It was a way of being with him that way again. Now I turn to those books every time I feel troubled. I never grow tired of them.

You're now a writing teacher. Do you think that someone can learn how to be a good writer, or do you agree with those who say that writing can never be taught?

I definitely think writing can be taught. There is a lot of technique to writing, just like there is technique around any art form. A potter has to learn about glaze and the heat of a kiln. A painter has to learn about prepping the canvas, and the qualities of oil versus acrylic. And I'm sure they throw away as many pots and canvases as we do drafts.

It's important to remember that a writer has things to learn too. They may seem less tangible because they have to do with training your ear for the sound of language, or with stepping back from a piece bit by bit, until the author is invisible and the sentences say exactly enough—not too much and not too little. But with practice and desire these things can be learned.

66 I definitely think writing can be taught. There is a lot of technique to writing, just like there is technique around any art form. 99

8

I think that one of the most difficult things about writing is that, unless you are under contract, you have endless opportunities to tinker. A ruined pot is a ruined pot, but a piece of writing can be played with forever. One of the most important things to learn is how to listen to your characters and your own instincts. If you don't learn that, you may never actually stop writing one thing and begin writing another.

What's the most important piece of advice you would give to a young writer just starting out?

I would say get used to writing regularly and a lot. And don't think that every piece of writing has to be perfect, or publishable. I've found a lot of value in practice and play. Doing timed writings in a group not only gives me a stock of ideas for stories or novels, but it also fires me up. It encourages me with the other aspects of writing that are lonely and sometimes not so much fun. So have fun with writing. But don't expect it to always be fun.

Do you have any housecleaning tips?

My most valuable piece of advice is to never hire a writer to clean your house. ～

> " Don't think that every piece of writing has to be perfect, or publishable. I've found a lot of value in practice and play. "

Writing Advice from the Author

OVER THE YEARS I have received a lot of free advice on how to be a writer (see page 70 of *A Broom of One's Own*). Here is my free advice rebuttal:

1. You must spend some time living abroad.

It's good to get out of your comfort zone, but the truth is that it's important to increase your powers of observation, wherever you are. Keep paper and pen with you at all times. Get into the habit of making lists of the things that you see and hear. Pay attention to the real way that people talk. Be specific when you record your observations. Do not write "Bird. Tree. Car. Man in Suit."

A bird's nest cupped inside a bowl inside an old, abandoned house. A huge wisteria vine broken through a window and winding around one room of another old house. A staircase in a friend's house with each tread painted a different color.

I observed and recorded these things years before I used them in my novels. The very act of writing things down will help you remember them, and it is these small collectible details that will help you build a believable fictional world.

2. You must trade in your Mac and write on a PC.

Use the tools you love. For me it is my Mac iBook, my Johnny Depp spiral notebook, two favorite pens, one favorite pencil, and a Pink Pearl eraser. In my backpack I also carry a pair of earplugs for writing in restaurants where the TV is kept on.

3. You simply must read Proust.

You can't read everything, so read what resonates with you. Don't be intimidated by other people's reading lists and tastes. Read what you like, and thereby discover what you would like to write.

Learn to read critically. When you read a passage that moves you, go back and reread it. Try to discover why it moves you. When you emote while reading, ask yourself, how did the writer do this? I think you will discover that good writers rarely tell you what their characters are feeling. Instead they convey emotion by showing how the characters are interacting with other characters and their surroundings.

Notice also turns of phrase that you like, descriptions, metaphors. It is okay to record these in your writer's notebook. Just transcribing them onto the page can give you a better idea of how this writer works, and of what you admire about him. ▶

“ Good writers rarely tell you what their characters are feeling. Instead they convey emotion by showing how the characters are interacting with other characters and their surroundings. **”**

Just don't claim anyone else's writing as your own.

4. You simply must subscribe to *The New Yorker*.

There's a lot of good writing in *The New Yorker* but you can subscribe or not subscribe as you wish. Pay little attention to people who tell you what you must do.

5. You simply must subscribe to every literary journal there is.

This is a hard one. There are a lot of wonderful journals out there that deserve our support, but the truth is, even if you have the money to subscribe to all these literary journals, you probably don't have the time to read them. And if you have the time to read them, you might not have the money.

Learning the writing life is about making choices. It's about making choices with your words, but also with your time and money.

6. Buy only hardback books.

Puhleeze!

7. Get an MFA in creative writing.

An MFA program is a wonderful thing and a great place to find support for your work. But remember that when you graduate, the MFA

community is no longer at your fingertips, and then you have to figure out how to write in a world that is very different from academia. So go for it, if it's what you desire, but make sure you develop independent habits that can carry you through a writing life that does not center on campus.

8. Go to an artists' colony.
It has never been my desire to go to an artists' colony, but that is probably because I don't travel well, and have always preferred home to any other environment. But for some people artists' colonies are invaluable. If you go, go to work, and beware of cocktail hour(s).

9. You have to attend lots of conferences.
You don't have to attend lots of conferences, but they are fun, and you meet a lot of wonderful people, make a lot of wonderful connections, and best of all, you can go home feeling charged about your writing. They can be expensive, so pick and choose. Sign up early so you can get in the classes you really want.

10. And you have to network, network, network, and never forget that everyone you meet is a potential source for something besides friendship. ▶

People are not commodities. Enough said.

And here's some bonus advice on developing your own writing life:

1. Write every day, and write at the time of day that is best for you. If you are a morning person, get up early and write. If you are a night owl, stay up late. Use your natural biorhythms to give your best self to your work.

2. Be ethical. Be yourself. Be honest. If you do not know who you are, do not know your own tastes and needs, you can be too easily lead down a literary road that is not of your own making. It is better to write one truthful thing that never sees print than to work the market and write twenty things that will pay your bills, but leave you wanting something deeper.

3. Be kind. Do not write for revenge. Do not vilify. If you are writing a memoir, understand that you will have to write about your own role in whatever event you are exploring. Nothing is ever everyone else's fault. A part of being kind is seeing the complexities of life and people, finding what is human in your

story. This does not mean being dishonest (see #2).

4. Develop good work habits and learn to trust the process. The bad news is that you can't get it right the first time around; the good news is that you don't have to. Realize what a first draft can give you compared to what a third or fourth draft can provide. Learn to write a first draft quickly, almost without thought. Then learn to edit. Learn to let go of things, and add other things. Learn to look at your writing as a reader. This is the work of second and third drafts.

5. Find your writing community. They need you and you need them. Find or start a writing group. But beware of some groups. If the group makes you want to quit writing, it's not a good group for you. If a group makes you want to keep writing, it is a good group for you. Take people's advice and then filter it for yourself. Some people will say things that resonate with you, and some will say things that feel wrong for your story. Learn to listen to them, but don't forget to listen to yourself. ▶

6. And finally—it is not necessary (as some people will tell you) to be fearless. It is only necessary that you have the desire to write, and that you are willing to do the work. If you are very fearful, as I am, go ahead and say it. Write it down. I'm scared. I'm scared of what my writers' group is going to say about my novel. The morning after *Life Without Water* was critiqued by my writing group, I burst into tears as my coffee brewed. It's not that they were mean or unkind. They had been gentle and helpful. And that I was crying in my kitchen was a complete surprise to me. It was emotional. Writing can be very emotional. But you can get through it. I did.

Here are some of the prompts I've used in my current class, called Prompt Writing. We meet once a month for communal writing. I set a kitchen timer (get one that doesn't tick) for fifteen minutes and we start writing using a prompt as a jumping-off point. The rules are to start writing and keep writing. Don't try to edit as you go along. Don't worry about staying on topic. If you get stuck, just write "I'm stuck, I'm stuck, I'm stuck," until you break through

the logjam. I guarantee you will. Just let the writing take you where it wants to go. When you read out loud to each other, it is important to never criticize. It would be unfair to critique something that has been written in fifteen minutes. Instead cite back to the writer what you liked about a piece. Cite scenes, phrases, details, dialogue, or any themes you might have noticed. This type of group is uplifting. The practice of timed writing can provide you with material for more polished writing. It is also fun and inspiring to hear other people's stories.

1. Use as your opening line: On TV they make _____ look easy.
2. Write about what's in your refrigerator. (Incidentally, this is a good exercise for characterization. You can tell a lot about people by what's in their refrigerator.)
3. Read an excerpt from *The Things They Carried* by Tim O'Brien and then write about a time in your life when you carried something (a diaper bag, school books, laundry, beer?). And while you've got the book in hand, go ahead and read it. It's excellent.
4. Write about a smell from your childhood. ▶

5. Find a picture of a place (*National Geographic* is an excellent source of intriguing pictures), and then ask yourself the question, What was lost here?

6. Using the same picture or another ask yourself, What was found here?

7. Write a scene in which a character is packing a suitcase.

8. Write about what you ate as a child.

9. Go to the paint store and randomly pick up a paint chip. Write a scene in which a character is painting his or her room this color (Sea Island Green? Plum? Chinese Red?).

10. Write about something stolen. ∽

Recommended Books on Writing

Art & Fear: Observations on the Perils (and Rewards) of Artmaking by David Bayles and Ted Orland

The Right to Write: An Invitation and Initiation into the Writing Life by Julia Cameron

The Woman Who Spilled Words All Over Herself: Writing and Living the Zona Rosa Way by Rosemary Daniell

Writing Down the Bones: Freeing the Writer Within by Natalie Goldberg

The Courage to Write: How Writers Transcend Fear by Ralph Keyes

On Writing: A Memoir of the Craft by Stephen King

Bird by Bird: Some Instructions on Writing and Life by Anne Lamott

Deep Writing: 7 Principles That Bring Ideas to Life by Eric Maisel

Write Your Heart Out by Rebecca McClanahan

On Writer's Block by Victoria Nelson

Seven Steps on the Writer's Path: The Journey from Frustration to Fulfillment by Nancy Pickard and Lynn Lott

A Writer's Book of Days: A Spirited Companion and Lively Muse for the Writing Life by Judy Reeves ▶

Recommended Books on Writing (*continued*)

Writing Alone and with Others by
 Pat Schneider
Making Shapely Fiction by
 Jerome Stern
*If You Want to Write: A Book About
 Art, Independence, and Spirit* by
 Brenda Ueland ∾

Don't miss the next
book by your favorite
author. Sign up now for
AuthorTracker by visiting
www.AuthorTracker.com.